IMAGES
of America

HARRISON

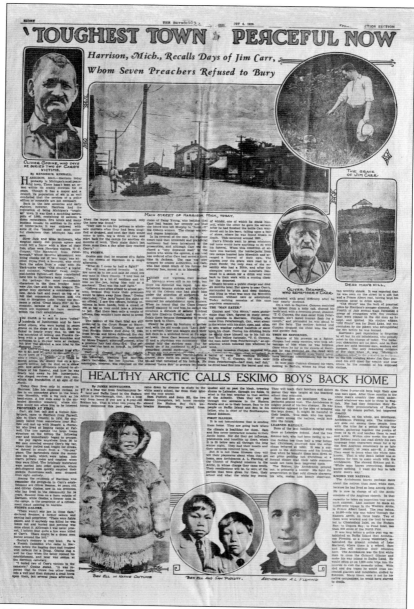

This *Detroit News* article from August 4, 1929, formed the basis for much of Harrison's lumber-days history. Oliver Gosine and Oliver Beemer, longtime friends and both residents of early Harrison, told tales of bad men, funny characters, and events that would be repeated and often misquoted in every history of the area for over 80 years. (Harrison District Library.)

ON THE COVER: The WH&FA Wilson Lumber Company mill in the early 1880s began the thriving economy of Harrison. Built between the budding town and the lake, it processed lumber from 1,800 acres of prime timber owned by the two Wilson brothers and a cousin. The company formerly operated in Vernon Township in Isabella County. (Harrison District Library.)

IMAGES
of America

HARRISON

Angela Kellogg and Cody Beemer

ARCADIA
PUBLISHING

Published by Arcadia Publishing
Charleston, South Carolina

Printed in the United States of America

Library of Congress Control Number: 2013945689

For all general information, please contact Arcadia Publishing:
Telephone 843-853-2070
Fax 843-853-0044
E-mail sales@arcadiapublishing.com
For customer service and orders:
Toll-Free 1-888-313-2665

Visit us on the Internet at www.arcadiapublishing.com

*Dedicated to the memories of Oliver Gosine and Oliver Beemer,
two characters the likes of which Harrison will never see again.*

CONTENTS

ACKNOWLEDGMENTS

Thank you to the staff and board of directors at the Harrison District Library for their encouragement and assistance as this book took shape: Mary-Jane Ogg, Mary LaValle, Deb Prince, Richard Hilton, and Courtney Doyle.

Thank you to Sheila Bissonnette, director of the Harrison District Library, for all her support and encouragement of "special projects."

Many thanks to those who were enthusiastic about the book and so willingly shared images and knowledge with us: Bill Faber, Judy Heintz, Jared Clouse, Jon Ringelberg, Joe Bradley, Richard Vershave, Matthew Smith, Betty Adams, Lillian Leposky, Merle Bailey, Les and Jamie Kellogg, Shelley Schultz, Joanne Ferguson, Dexter Russell, Bill Beemer, Robert Knapp, Rick Prosser, Tom Hecker, Oliver Beemer, Marty Bucholz, George Dunham, Genine Hopkins, Barbara Lambdin, Kathy Endert, Dave Carmine, and Jeff and Tammy Brokaw of *The Forestry Forum*.

Thank you to Rose Marie Stevens for her love and support.

A heartfelt thanks to Cody's wife, Misty Beemer, and Angela's significant other, Barry Henry, for their patience and understanding.

Thanks to Andy Coulson for all his creative research; his enthusiasm for preserving history is inspiring, and his collaboration was invaluable.

Thank you to Pam Mayfield and staff at the clerk/register of deeds office for their valuable assistance and professionalism in preserving and providing access to county records.

Much appreciation and admiration to Anne Smith for laying the groundwork for the exceptional historical collection at the Harrison District Library and the Harrison centennial materials that proved invaluable in the writing of this book.

To all the past keepers of Harrison history, we honor you: Forrest Meek, Tom Sellers, Clarabelle Mixter Titus, Marie Beemer Bailey, Leonard Hawkes, Roy Allen, Katherine Briggs Funck, and many more.

A special thank you to Nick Loomis, without whose dedication and assistance this project would not have been possible.

Images in this volume appear courtesy of the Clare County Historical Society (CCHS), the Forrest Meek Collection (Meek), and the Beemer family (Beemer), and others. All unattributed images are from the collection at the Harrison District Library.

INTRODUCTION

Half a century after Harrison's beginnings in the unbroken wilderness of Northern Michigan, and just a few years less from its heyday as "Michigan's toughest town," its reputation was still being talked about at least as far away as Detroit.

In 1929, *Detroit News* reporter Kendrick Kimball came to Harrison to track down and interview any of the old lumberjacks ("jacks"), brawlers, and tough guys who might still reside in the now peaceful town, hoping to record the story of Harrison's glory days of the lumber era. He found two men who had been through it all: Oliver Gosine and Oliver Beemer. Both had been shanty boys and lumberjacks in the woods around Harrison. Gosine had been a cook in the lumber camps and later foreman of the Wilson Brothers ice-cutting crew, while Beemer had been a saloon owner in both Clare and Harrison and later a Prohibition-era whiskey runner and rumored affiliate of the Purple Gang.

The aging newspaper hung in several Harrison businesses, but the copies were lost over the years. The article will be familiar to readers of many books, pamphlets, and other historical accounts of Harrison. It has served as the basis for almost every account of Harrison since it first appeared. Many authors have used quotes and information from the article with no reference to the firsthand account. Whether it is fact or fiction is up to the reader to discern as the stories are reintroduced and one is taken back to Harrison when it was Michigan's toughest Town.

The lumber era of Northern Michigan is often romanticized, and titles like "toughest town" are points of pride. The darker side of the impact of such a place on the environment and its people is often overlooked. The aftermath of the pillaging of the forests around Harrison was felt for many years. Only a small percentage of the businesses, jacks, and residents stayed to make Harrison their home.

The people of Harrison were barely affected by the Great Depression. Most of the residents were already as poor as they could get, living off of subsistence farming or hunting for additional food and income to supplement what jobs and local business provided. There was very little economic base. Many residents worked out of town and maintained their homes and families in Harrison. In those days, that meant punishing drives by Model T from Detroit, Lansing, or Flint just to see their families. Most of the buildings in town were in need of repair or close to being condemned. Few city streets were paved, and side streets were overgrown with high grass.

Even when the town was in its infancy and lumber was king, newspapers reported the potential for Harrison as a summer resort community. They recognized even then the potential for the lakes, fishing, rolling hills, and fresh air to bring people north. The popularity of the automobile and tourism would soon begin to bring prosperity to the area. Rental cabins, seasonal homes, and characters like "Spikehorn" Meyers all enticed travelers to stop and enjoy Harrison.

The greatest growth occurred in the 1940s during World War II. Factories producing war materials and automobiles were operating at capacity, and city workers were excellent prospects to own a cabin in the north woods. Advertisements in Bay City, Midland, Flint, and Pontiac newspapers offered cabins and lots as a package deal, and several subdivisions surrounding Harrison were created as seasonal communities. Cabins were sold for $695, with $100 down and payments of $35 per month.

Many of the seasonal property owners would later retire to the Harrison area, expanding and remodeling cabins into year-round homes. Generations of Lower Michigan families continue to enjoy the four seasons of recreation that Northern Michigan offers through properties passed down from parents and grandparents.

The City of Harrison continues to maintain and improve the services and quality of life that began in the early days when it was a just a village. The first ambitious residents' vision to

create a community out of the howling wilderness with a prosperous and healthy environment has been realized.

The following is from Kimball's 1929 newspaper article. Our intent is not to add or detract from the original article but to offer it back to its community in its entirety—the holy grail of Harrison's lumber-era history:

Harrison today is probably Michigan's most peaceful town. There hasn't been an arrest within its scanty environs for 10 years. Though it has a mayor and a council, its population of 400 is so well conducted that the services of a police officer or a constable are not necessary.

Back in the late 70s and early 80s, however, Harrison had the reputation of being Michigan's "toughest" town. It was then a sprawling metropolis of 2,000, containing 22 saloons, a dozen restaurants, 5 hotels and many business houses. In addition to its army of lumberjacks, it was endowed with some of the "hardest" and most colorful characters that Michigan has ever seen.

Silver Jack and Mike McGovern, who weighed nearly 300 pounds apiece and could fell a horse with a blow of their fists, often were Harrison visitors. T.C. Cunyan, "The Maneater from Peterborough" whose favorite amusement was biting chunks out of beer mugs, was another. Dryas Ford, a teamster, who could fleck the ashes from a cigar with his black snake whip; "old Schutz," a loafer and nuisance; "Crankie" Dean, a rough and tumble fighter—all these contributed lurid bits to Harrison's early history.

But perhaps the most redoubtable characters in the then frontier town were Jim Carr, and his wife Maggie. Together they operated a combination saloon, dance hall and resort on top of a hill that commands Harrison and the road to Houghton Lake. Today the eminence is called "Dead Man's Hill" by the romantic, because of the dark deeds which are supposed to have occurred within the Carr establishment.

Jim Carr is said to have "rolled" hundreds of lumbermen and to have killed others, who were buried in secret graves on the slope of the hill. He trafficked in nearly every vice. In 1888 he was convicted of killing one Frankie Osborn with a pair of brass knuckles and sentenced to a 15-year term at Jackson, but was later granted a new trial by the Supreme Court.

How Carr's fortune went from $75,000 to $3; how he went to the now abandoned town of Meredith where he operated a resort on runners so it could move across the county line on a moment's notice; how he died on a straw pile; how seven ministers refused to officiate at his funeral; and how he was finally laid away by 500 lumberjacks, who staged services of their own, constitute the foundation of an epic of the north.

Today Carr lives only in memory in Harrison. Like his supposed victims, he lies in an unmarked grave in the brush near Meredith, with a big rock as his head-stone. A few rods away are the untended Meredith cemetery, where citizens would not allow him to be interred.

PROSPERED AT FIRST

Carr, six feet tall and a former lumberjack, came to Harrison form Farwell, also in Clare County, in 1876. He was originally hailed from somewhere near Buffalo and met up with Maggie, a character who lived at logging camps at Farwell. The two operated the large framed structure on the hilltop the following year and immediately began to prosper.

On pay night anywhere from 50 to 200 men crowded around Carr's big bar where they jostled and fought for drinks or danced to music from a "tin-pan" piano. The bartenders threw the money into tin pails, where they were taken to Carr's private room and emptied when they were filled. The helplessly inebriated were carried into other quarters, where deft-fingered aids quickly emptied their pockets. Sometimes such men dropped from sight entirely.

Among the residents of Harrison who remember the goings-on in Carr's establishment are Oliver Beemer, 84 years old, and Oliver Gosine, now in his seventies who have lived

in the community for 54 years. Beemer lives on a farm outside of Harrison, while Gosine, a former cook in the camps, is the proprietor of a refreshment stand catering to tourists.

FIGHTS GALORE

"There wasn't any law in those days," declared Beemer, a former saloon and gambling hall proprietor. "There were fights galore, and if anybody was killed he was taken out and buried and nothing was done about it. Although I was never present, I believe that quite a few were killed at Carr's. There might be a dozen men buried around the hill."

Gosine's memory is very keen. He is a French Canadian who came to Harrison before the logging days and trapped wild turkeys for a living. Gosine dug a well for Carr when the latter opened his establishment, and later was sexton in the Harrison cemetery.

"I buried two of Carr's victims in the cemetery." Gosine stated. "It was reported that he threw two other bodies into a well and then dumped a dead horse upon them, but several years afterward, when the report was investigated, only the horse was found."

"Carr used to rob his patrons in wholesale numbers after they had been stupefied or drugged, and the next day they would come to town, beg a drink or two and start back for the camps for another six months of work. Their stake didn't last them more than a day after they reached Carr's."

27 ½ FIGHTS

Gosine said that he counted 27 ½ fights on the streets of Harrison in a single afternoon.

"What do I mean by a half a fight?"

The old man smiled broadly, "A fellow came up to me and said he could lick any man in Clare County. I told him he was taking in a lot of territory and hit him on the jaw, laying him cold as mackerel. That was the half fight."

"Officers were afraid to arrest a person, because they knew their prisoners would be taken away from them," Gosine concluded. "The jacks' hated the sight of an official. I saw five officers, holding revolvers in both hands; hold a crowd of 200 at bay so they could take a prisoner to jail. Had there been only a couple of officers, they wouldn't have dared to arrest him."

The records of the Carr trial are still preserved in the Court House at Harrison, and of Clare County. They show that Frankie Osborn died June 16, 1884, from bruises and blows delivered the day before. The prosecution was conducted by Moses Taggart, attorney general, after a previous jury had disagreed. The second trial was held at Ithaca, in Gratiot County.

Testimony showed the Osborn woman exonerated Carr in an ante-mortem statement, blaming Murphy, Carr's Bartender, for her injuries. The conviction, however, was obtained on the claim of Daisy Young, who testified that Carr had beaten her severely and that she heard him tell Murphy to "finish off" the Osborn woman. The charge was second degree homicide.

In its reversal of the case, the Supreme Court held that irrelevant and prejudicial testimony had been introduced by the prosecution, and although Carr was declared a "very depraved man" by the justice who wrote the opinion, a new trial was ordered after Carr had serve a short time in Jackson. The case was later dropped by county authorities, and Carr who had spent much of his fortune for attorney fees, moved on to Meredith.

Prime and vigorous, Carr reached Meredith when still in his fifties, but here his downfall was rapid. Law enforcement became stricter and the notoriety of the Osborn case had placed him under the alienation of authorities. As an expedient to thwart officials, he mounted his establishment upon runners. When he heard that the Clare County sheriff planned to raid him he moved the structure a distance of several hundred feet into Gladwin County, and when officials there became threatening he would move back to Clare.

Finally he gave up business altogether and, with the old woods cook "Lame Bob" as a servant, Carr and Maggie spent their last days in a wretched hovel at the edge of town. Soon

Carr became desperately ill and a physician was summoned. The doctor told the stricken man that he would die if he continued to drink and prescribed several medicines.

From his bed Carr threw the medicine out of the window and, reaching into a drawer, drew forth his purse, containing $3—all that remained of his fortunes. He ordered "Lame Bob" to procure two quarts of whisky, one of which he drank himself, while the other he gave his servant. After he had finished the bottle Carr wandered out to his barn, falling upon a bale of straw, where he was found frozen to death. This occurred around 1900.

Carr's friends went to seven ministers, but none would have anything to do with his funeral. When this condition of affairs was learned, the lumberjacks from two camps hurried into Meredith and arranged a funeral of their own. The prayers over the grave were read by a giant Swede, the only man of the assembly who had a Bible, and after the obsequies were over the mourners hastened to a saloon for a drink and went back to their work with a rousing cheer for the departed.

Maggie became a public charge and died six months later. Her grave is near Carr's surrounded by brush and deep thickets and lying in what was once the Meredith commons without care or adornment. Today nothing remains of this once populous community.

THE "MANEATER"

Cunyan and "Old Shutz," more picturesque than Carr, figured in many amusing episodes in Harrison. Cunyan, who came from Peterborough, Ont. went about in the winter with his shirt open, and often in zero weather rubbed handfuls of snow upon his chest. During his drinking bouts he would draw himself up to his full six feet and bellow furiously, "T.C. Cunyan, the man eater from Peterborough," an appellation which followed him wherever he went.

On one occasion Cunyan ventured into a saloon that contained a barrel of water for washing purposes. Yelling "T.C. Cunyan, the Man-eater from Peterborough-half man, half fish," he dived head first into the barrel and was extricated with great difficulty after he nearly drowned.

On a visit to Saginaw, Cunyan snatched an infant from a baby cab, showed his teeth and, with a ferocious growl, said, "T.C. Cunyan, the man eater from Peterborough, ain't tasted human flesh for a month" and pretended he was about to eat the baby. The mother fainted and Cunyan dropped the child into the cab and quickly fled.

THEN HE REFORMED

Because of his prowess as a fighter Cunyan had many enemies, who took advantage of him when he was helpless. Once when he lay in the streets of Harrison he was pounded on the head with a stone. Any ordinary man would never have recovered consciousness, but he was little affected.

In later years Cunyan changed his ways, moving to Buffalo, where he lived with two wealthy sisters. It was reported that he was seen on the street in a silk hat and a Prince Albert coat, having kept his promise never to drink again.

"Old Shutz" was the bait of practical jokes by Harrison's younger element. One Fourth of July several wags furnished a group of youngsters with fire crackers that were pinned to the old man as he slept, and ignited. His clothes aflame "Old Shutz" ran for Budd Lake, but was overtaken by the jokers, who extinguished the fire before he was burned.

Harrison's past reputation is forgotten by all but its old inhabitants, who proudly point to the change of today. The turbulent characters are no more, and in their place are solid business men, workers and farmers. The only remaining evidence of the day when it was "Michigan's toughest town" is the waterworks building on the hill, standing where Jim Carr pursued his evil quest for wealth and near where lie the remains of his supposed victims.

One

LUMBERING

TOUGHEST TOWN

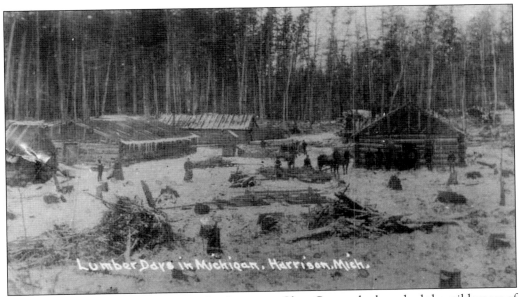

The northeastward expansion of the lumber era in Clare County had reached the wilderness of Budd Lake Station by late 1870s. Later named Harrison, this rough camp was one of the first in the area. Harrison was most likely named in honor of the ninth president of the United States, William Henry Harrison. Alternate stories claim the town honors Harrison Carey, one of the first surveyors in the area, or Harrison Calkins, the first child born in the village, on April 9, 1880.

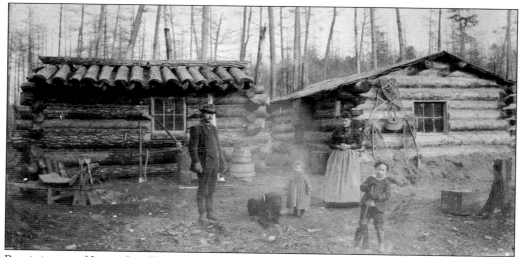

Reminiscent of Laura Ingalls Wilder's *Big House in the Woods*, the homestead cabin represents early life in Harrison. With all their worthy worldly possessions on display, these family members may be preparing for winter, with snowshoes at the ready and the cabin insulated for winter. The unusual roof shows the ingenuity of the early homesteaders.

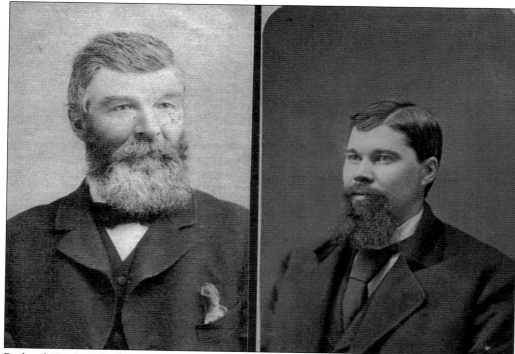

Richard "Dickie" Budd received a land grant in 1873 of 120 acres in Hayes Township, and he is widely assumed to be the namesake of Budd Lake. According to local lore, he climbed a tree and spotted Budd Lake. The Budd family, including brothers Richard (right), William (left), Thomas, and Isaac, were the earliest Budds to inhabit the area. In 1887, it was listed as "Harrison's Lake" on a railroad map, but the name Budd persevered. Many Budd family members remain in the area today. (Courtesy of the Budd family collection.)

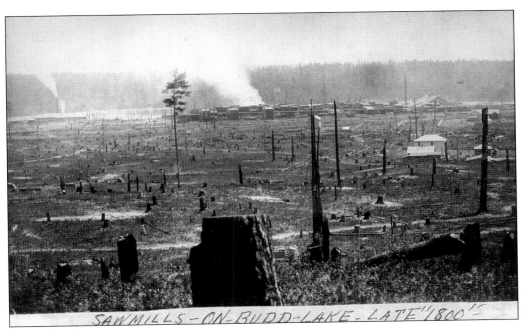

SAWMILLS - ON - BUDD - LAKE - LATE "1800'S

Above is one of the earliest photographs of the Wilson Lumber Company mill and what would become the location for the village of Harrison, having just recently been carved out of the wilderness. What may look like shanties or crude cabins around the mill are stacks of lumber with the tops slanted for rain runoff. The Wilsons' shingle mill sits to the far left. Below, a ramp rises along the stacks of lumber steadily from the mill for a rail system for handcarts that were used to stack large amounts of lumber. The lumber seen here is stacked for drying and ready for transport.

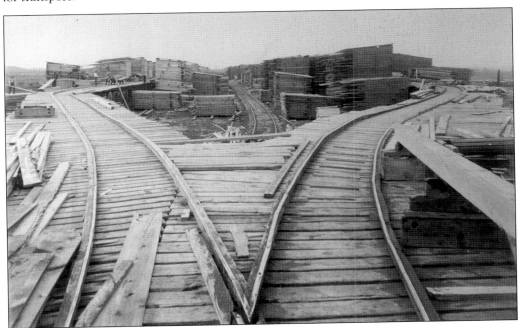

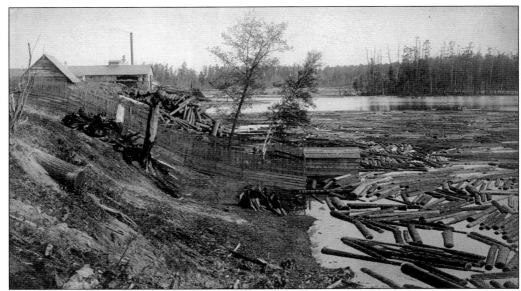

Here, logs float on the west shore of Budd Lake. With no outgoing streams or rivers, the logs are most likely being stored for preservation from fire, insects, and rot until they can be processed at the mill. The logs were contained from floating out into the lake by a perimeter of logs held together by chains. W.H. Wilson referred to this as his "log boom." The island on Budd Lake is just off shore, and up the slope of the bank are Wilson's Mill and the hub of lumbering around Harrison.

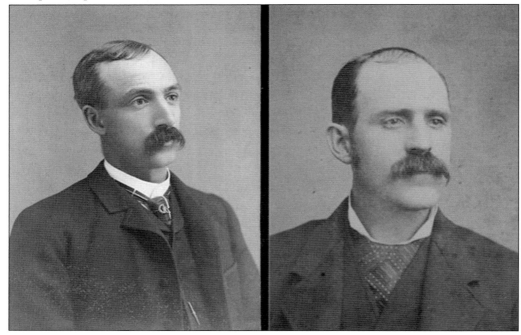

The Wilson brothers moved their families to Harrison in 1881. Farwell Wilson (right), commonly referred to as F.A., was later elected to the state legislature. The only Wilson to remain in Harrison, he passed away at his home on Lake Street in 1896. William Hotchkiss "Stick" Wilson (left) was the first mayor of Harrison. Their third business partner was their cousin William Henry Wilson.

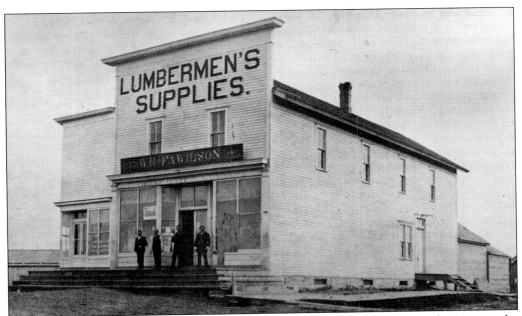

The Lumbermen's Supplies store was a necessity and an excellent companion business to the mill. The store would be a starting point for all nearby camps. The Harrison area at this time was surrounded by dozens of lumber camps and hundreds, if not thousands, of lumberjacks. The store was a convenient hub for all the supplies the men, foreman, cooks, and surveyors could hope to purchase. Until Meredith became a boomtown, the store was the last stop for supplies to points north. (Meek.)

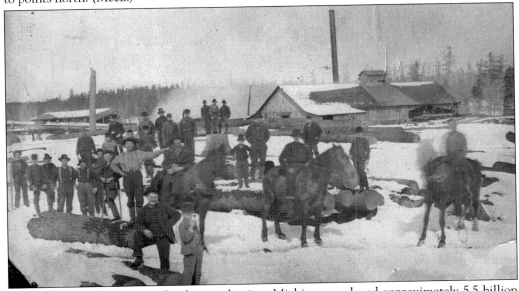

In 1889, the year of greatest lumber production, Michigan produced approximately 5.5 billion board feet. While the grand total of Michigan log production may never be known, it has been estimated at 160 billion board feet. Considering the enormity of early wastage and lack of good record keeping, this may be a conservative estimate. This is one of the earliest photographs of Wilson's first mill on Budd Lake.

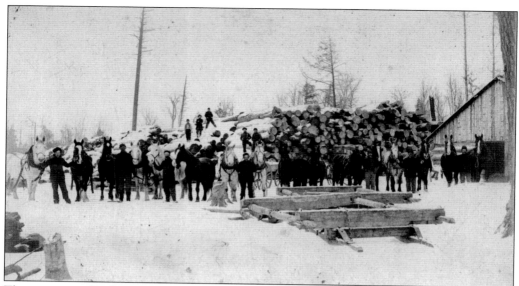

The teamsters of Wilson's lumber camp were men who could ably control and handle horses; they earned a higher wage than the average "shanty boy." The two sleighs in the foreground were built on-site in the camp. The horses pulled huge loads over skid roads iced down in the wintertime and were outfitted with spiked horseshoes to maintain traction. (Beemer.)

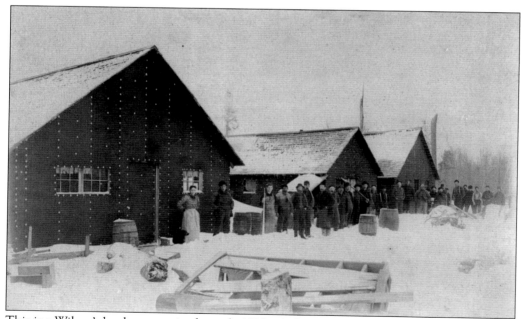

This is a Wilson's lumber camp in the early 1880s. A dining hall and kitchen, sleeping quarters for the men, office, and foreman's quarters would have made up an early lumber camp, along with a stable for the teams of horses, sometimes oxen, and a blacksmith and tinker (wood worker). The presence of a woman in the camp, while atypical, was not uncommon, as wife or family members of the cook or foreman would sometimes share camp duties. (Beemer.)

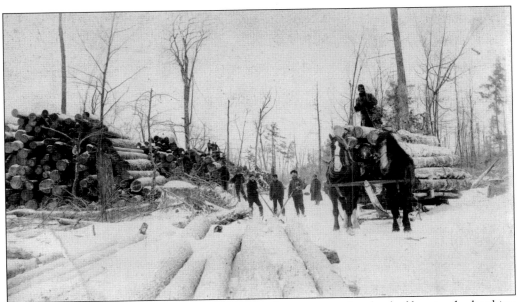

This is a team of horses at Wilson's lumber camp bringing another load of logs to the banking ground. As labor intensive as it would have been to pile the logs so high, it would pay off in the spring when the railroad was graded and laid alongside these piles. The loading of the train cars was quicker and more efficient, moving the most logs the shortest distance onto the cars. (Beemer.)

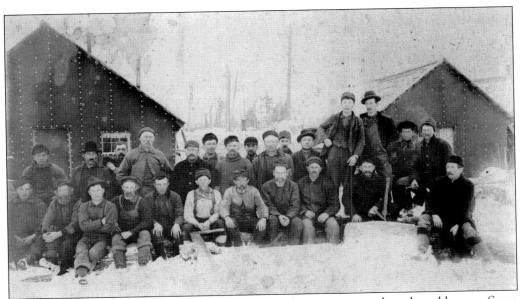

The men of Wilson's lumber camp, known as shanty boys, were a rough-and-tumble crew. Some were lifelong woodsmen from the Eastern states, and many were recent immigrants (mostly northern Europeans). The men's work and often-ultimate sacrifices in the woods made far-off lumber barons into millionaires. (Beemer.)

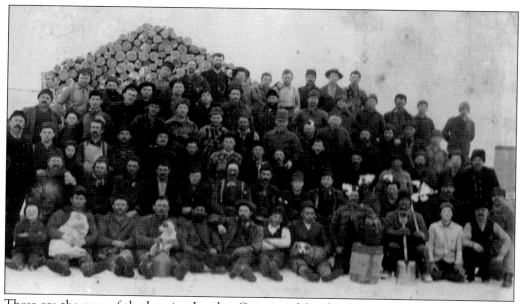

These are the men of the Lansing Lumber Company. Most lumbering was done in the winter, which lessened the risk for bugs bites, disease, and heat exhaustion. Working in the woods provided winter work for the pioneer; a man and his family could farm in the summer, and he could go to the woods to make additional income during the cold months. (Beemer.)

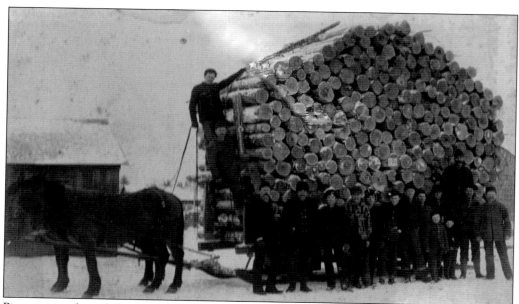

Pine was not the only lumber of value harvested in Northern Michigan. Here, the Lansing Lumber Company at Dodge City hauls a large load of cedar, probably to be used as fence posts. As the land was cleared for farming, cedar posts would have been in great demand. (Beemer.)

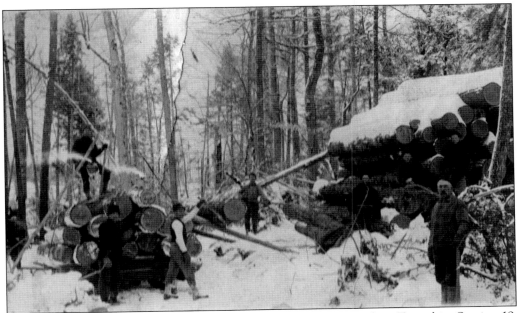

The Lansing Lumber Company started the town of Fisher in Hamilton Township, Section 19, when they set up a sawmill about 1884. Their landholdings were about 2,700 acres with some land also in Arthur Township. The town of Fisher is now known as Dodge City. The name changed when Orlando F. Barnes and William H. Dodge bought out the main stakeholders of the Lansing Lumber Company. (Beemer.)

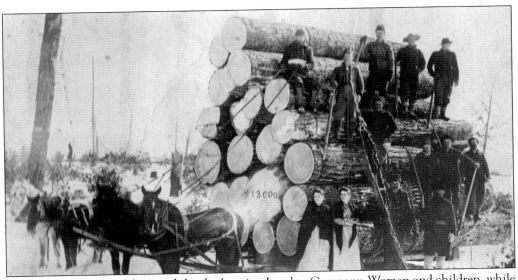

Pine was hauled out of the woods by the Lansing Lumber Company. Women and children, while unusual, were not unheard of in lumber camps. Cooks and foremen had private quarters and often brought their wives and families along. (Beemer.)

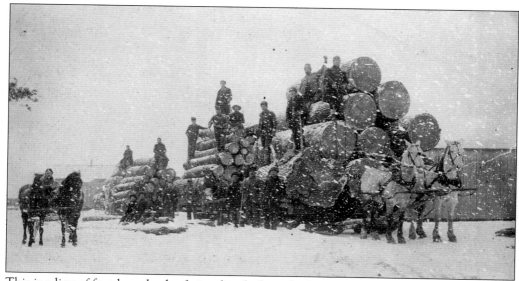

This is a line of four huge loads of pine, hemlock, and other types of wood. White pine was the preferred lumber of the time. A soft, good-quality wood, it took nails easily and rarely splintered. The large sawmill of the Lansing Lumber Company burned down in March 1894, making Dodge City an abandoned lumber town.

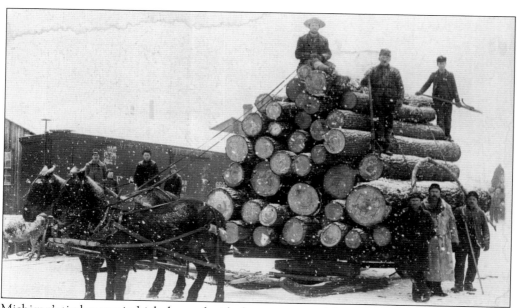

Michigan's timber was in high demand with the expansion of the Midwest and the rebuilding of Chicago. It was a race to get to the large stands of pine and other woods, and many men became millionaires very quickly. The natural resources of Clare County did not bring prosperity to its people. Taxes were rarely collected, most workers were transient, and money earned by the timber barons went with them to their home bases in Muskegon, Bay City, Saginaw, and elsewhere.

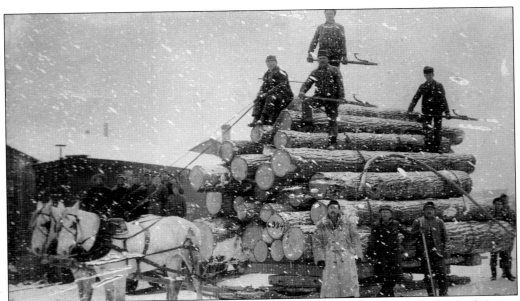

A branch of the Flint & Pere Marquette (F&PM) Railroad ran from the lumber town of Hatton to Dodge City. Hatton was another booming lumber town that could not survive after lumbering ceased and agriculture failed. This load carries hemlock; it was not the preferred wood for building, but the tannin was valuable when extracted from its bark to be used in the tanning industry.

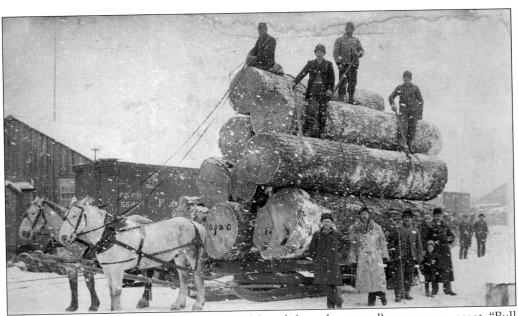

In this image, foreman Joseph Carrow (second from left on the ground) wears an overcoat. "Bull of the Woods" was a common term for a man who—by physical force, respect, or a combination of the two—could keep the rowdiest shanty boys in line. The men atop the load hold cant hooks, a traditional logging tool composed of a wooden level handle with a moveable metal hook used for handling and moving logs.

21

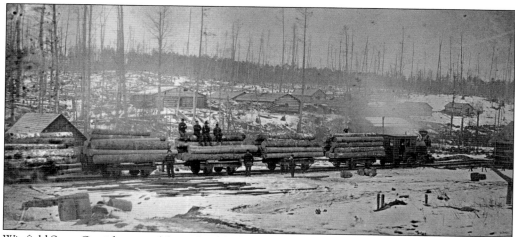

Winfield Scott Gerrish was widely credited for building the world's first narrow-gauge logging railroad from Lake George to the Muskegon River, beginning in 1876. While not the first in Michigan, it was the first in Clare County, and it revolutionized the logging industry in Northern Michigan. The Lake George & Muskegon River Railroad was originally a seven-mile, narrow-gauge railway with many branches added later. It used the traditional method of banking logs at the Muskegon River and waiting for the spring log drives to send logs to market. The rail car (center) clearly shows "LG&MRR" (LG&MR was more commonly used) in an 1880s photograph that has never before been published. (Courtesy of Jeff and Tammy Brokaw, *The Forestry Forum*.)

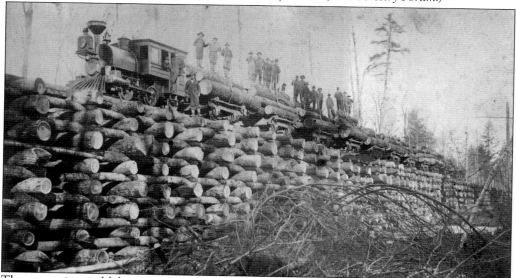

The expensive and labor-intensive feat of engineering by the LG&MR is documented here in a recently rediscovered photograph. Trestles such as this were only built when the means to get around a swamp or low area was not practical. The LG&MR was known for building many trestles out of logs; one as long as 550 feet has been recorded and is possibly the one in this photograph. For Harrison and the surrounding area of the Saginaw Bay watershed, it was the standard-gauge Flint & Pere Marquette Railroad that completely replaced the rivers and streams as a means of conveyance to move lumber to market from the cutting grounds. There is speculation that the LG&MR ran an extension to Harrison. It is known that plans for the Harrison branch were drawn on some maps prior to 1880. (Courtesy of Jeff and Tammy Brokaw, *The Forestry Forum*.)

This image shows two jacks southeast of Clare County sawing a tree into log lengths with a crosscut saw, commonly known at the time as a "misery whip." The work was hard and dangerous and left many a lumberjack's wife a widow. (Beemer.)

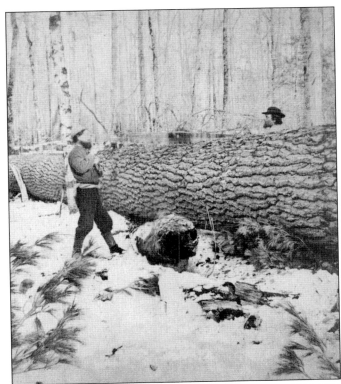

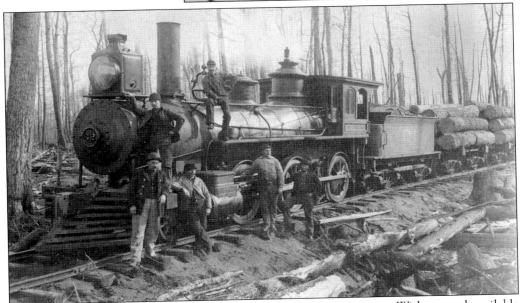

This is a newly laid standard-gauge railroad grade in the Harrison area. With no coal available in Northern Michigan, this steam locomotive burned wood as a practical alternative as wood was obviously abundant. So plentiful were treetops, branches, and stumps—the waste from the cut-and-run logging practiced in the late 1800s—that they often caught fire drying out. Later, screens called "spark arresters" were used on train smokestacks to prevent fires.

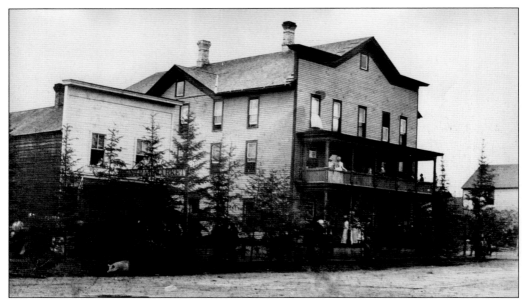

As the lumbering camps moved north, a new town called Meredith was established in 1883 in Franklin Township near the Roscommon and Gladwin County lines. The luxurious, three-story Corrigan House (center) opened in 1884 and, at 100 feet, supposedly had the longest bar in Michigan. The lawlessness in Meredith soon had a reputation that far exceeded Harrison's. (Courtesy of Earl and Edna Mitchell from the Endert family collection.)

Jim Carr and many other Harrison businessmen went to Meredith and capitalized on its growing population. Meredith was in constant controversy with fights, prostitution, murders, and general civil disorder. The buildings shown here are associated with the Flint & Pere Marquette Railroad operation in Meredith. (Courtesy of Earl and Edna Mitchell from the Endert family collection.)

Meredith's last brush with fame occurred when the Wilson & McNally Tobacco Company of Ohio bought a section of land and platted 3,990 lots. In a promotional sweepstakes, 16,000 deeds were given away as prizes. The township supervisor sent tax bills to every state in the union, but taxes were rarely paid. The board of supervisors petitioned the state, and its subdivisions were dissolved and its status as a village was officially ended in 1899. Shortly after, a fire swept through Meredith, leaving it in ashes. Note the lumber camp (center) that the town soon sprung up around. This view of Main Street looks south, with the depot on the right and many other businesses pictured. (Courtesy of Earl and Edna Mitchell from the Endert family collection.)

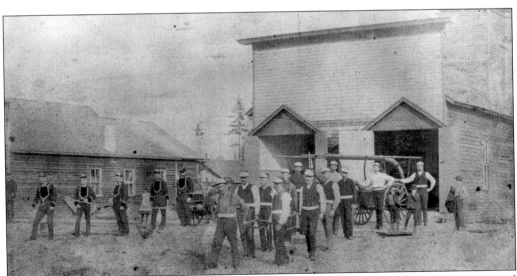

A fire brigade in Meredith was important, as the area was plagued by fires. A post office operated in town from January 14, 1884, until October 14, 1895. In 1893, the rails were pulled up, the depot was dismantled, and the crews moved on. (Courtesy of Earl and Edna Mitchell from the Endert family collection.)

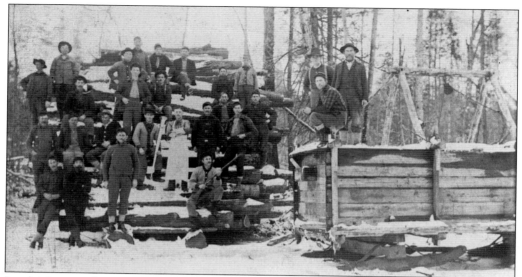

Ice sleighs are a forgotten aspect of the lumbering industry of Northern Michigan. The road to a lumber camp was as important as a Main Street to a town. Beginning with the first good freeze, the road was paved in solid ice, sprinkled at night for additional strength, tended constantly, and grooved for the runners of the loaded sleighs that traveled it. (Beemer.)

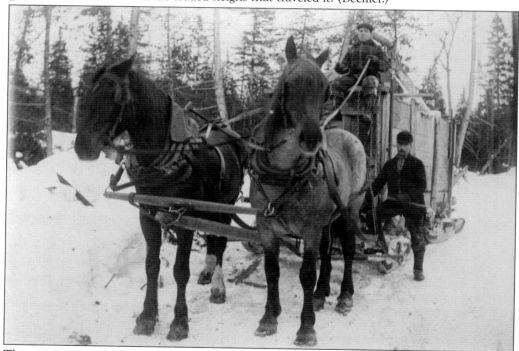

These men are icing the skid roads to allow the teamsters to pull huge log loads, an integral but often forgotten part of logging. It was not uncommon to have a load of 10,000 board feet, and the sleigh had to be able to move easily. Amos Toman (standing), a Canadian-born Civil War veteran, was a well-respected woodsman and later businessman, and he was one of the first settlers in Frost Township. (Beemer.)

Charles Bailey (left) and an unidentified companion pose in the studio of L.O. Moore. They wear boots with spikes referred to as caulks, which provided sure footing on wet logs in the river during log drives, and they hold cant hooks, used for rolling and maneuvering logs. Barely out of boyhood, they would have been working in the woods at a young age. Moore had a studio on Main Street in Harrison. He was later joined by L.S. Morey, and they had a second studio in Gladwin. (Beemer.)

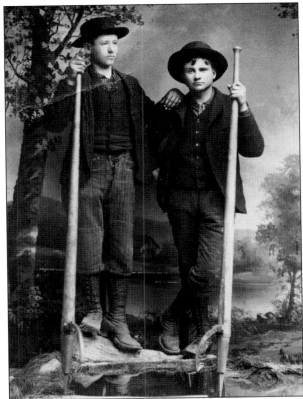

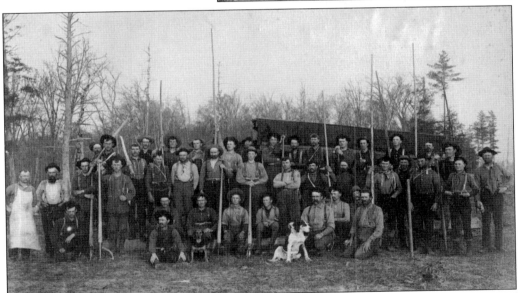

By 1894, the lumber industry was moving north, having stripped the Harrison area of most of its "green gold." In this previously unpublished photograph, hardy men pose at the last drive on Townline Creek, which may represent the last of the few river log drives in Clare County. Charles Bailey is in the center, holding a cant hook. (Beemer.)

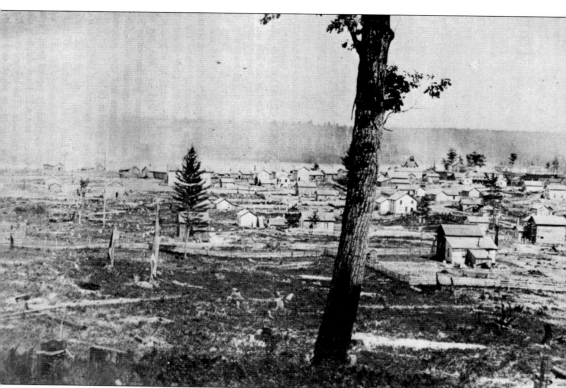

After the courthouse in Farwell was burned to the ground in July 1877, discussion ensued throughout the county about where to locate the county seat. Whether a matter of politics or lack thereof, the F&PM Railroad offered up any lot desired for the location of a new courthouse by the soon-to-be-built Budd Lake Station. Wilson's Mill was already carving a hole in the forest, and the railroad quickened its pace, laying track north in anticipation or possibly to help persuade county officials in the southern half of the county to make a decision. By 1878, it was put to a vote, and the citizens decided to move the county seat to this new and centrally located site.

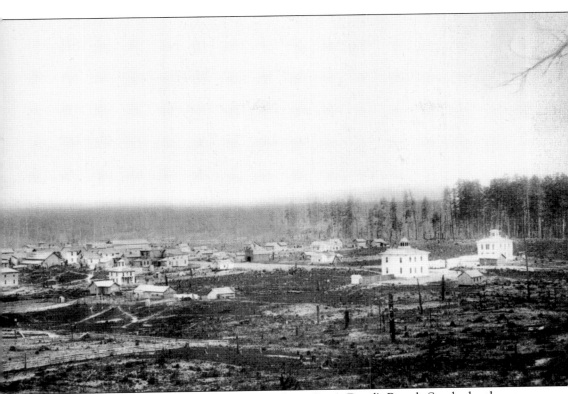

In a view from Dead Man's Hill, the location of Jim Carr's Devil's Ranch Stockade, the new courthouse (far right) and school sit shining bright and new with the barely cleared land of the village to the east and thick forest to the south. The site was cleared, and building began on September 20, 1879. The new town was springing up overnight. Prior to the building of the courthouse, also in 1879, a temporary log structure (directly in front of courthouse) was erected by Rueben Smith for $160 to be used for county business while the new courthouse was being completed. J. Lee Potts was a lawyer who lived next door to the courthouse block on Broad Street and Main street—recalled Tim Tarsney, later a congressman—who defended and cleared a man of murder in fight at a lumber camp in a trial held at the temporary log courthouse. The Honorable Henry Hart of Midland presided over the trial. After the new courthouse was occupied, the original one-room, log structure was leased to School District No. 3. It was used as a school until a new school was built and ready for use in 1881.

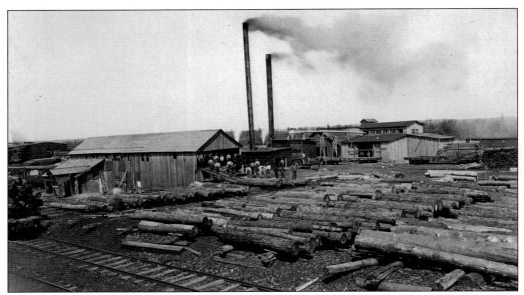

Thousands of trainloads of logs would have passed Wilson's Mill on Budd Lake on the tracks (lower left) to mills in Saginaw and Bay City. Other loads would have come to the mill from their cutting grounds and been processed into lumber, adding to the local economy. Some was used locally, and much was sent south on the rail. A sawdust pile marked the site of the mill for the next 50 years.

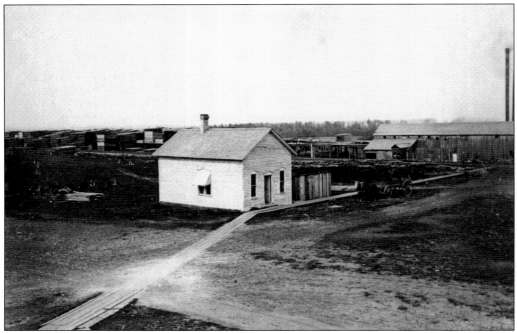

This is the office at Wilson's Lumber Mill. The uncut wilderness sits on the other side of the lake. In 1879, when the mill was established, Samuel Green and Enos Aldrich were paid a bounty of $8 each by the county supervisors for killing two wolves apiece. The building was later used as a home for many years.

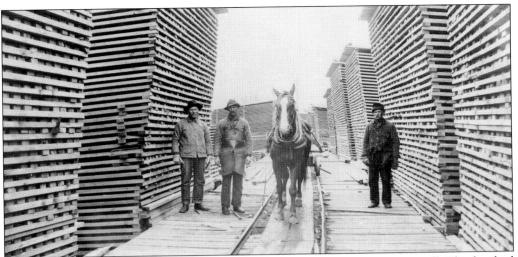

This is a close-up view of lumber stacked two stories high at Wilson's Lumber Mill. The finished lumber is spaced out for drying. The material would contribute to building the town of Harrison and would also be shipped to other areas of Michigan. The raised rail system was used by handcarts and horse-drawn carts, as shown here.

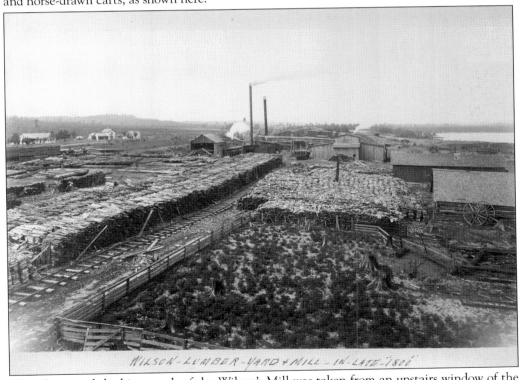

WILSON-LUMBER-YARD & MILL - IN-LATE-"1800"

This photograph looking north of the Wilson's Mill was taken from an upstairs window of the F.A. Wilson home on the corner of Main and Hill Streets (later renamed Lake Street). The wood in the foreground is refuse slab wood from the mill, used for fueling woodstoves and cookstoves in homes and businesses. The smokestacks have spark arresters, screens to block hot cinders and sparks, to protect the mill from fire.

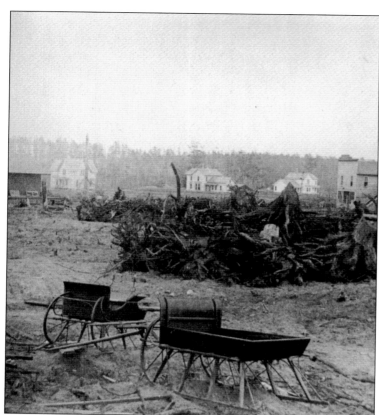

Main Street is strewn with stumps as this view looks east, with Budd Lake hidden over the hill break in the background. The Saginaw Saloon and Restaurant can be seen to the right and the depot to the left. The three new homes in the background bordering Lake Street are the mansions of the day, built by the Wilson brothers. (Beemer.)

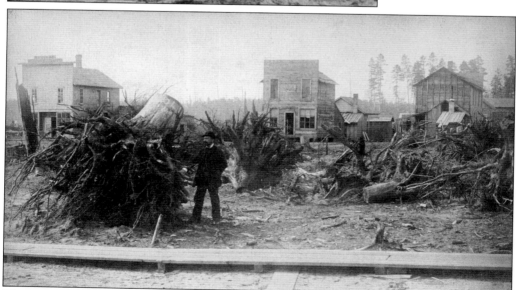

This is one of the most popularly printed photographs of early Harrison; in it, Main Street has just recently been stumped. In late 1880, John Cramer signed the contract and cleared two blocks of Main Street. Looking south, the building on the left is the Saginaw Saloon and Restaurant on the corner of Main and First Streets, now the location of Budd Lake Bar.

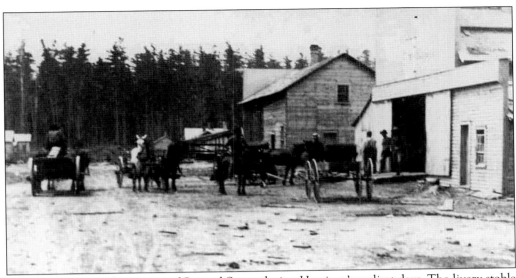

This is an 1882 southern view of Second Street during Harrison's earliest days. The livery stable is in the right foreground, and the future location of Fanning Groceries is the next building to the south. The city of Harrison was not officially incorporated as a fourth-class city until 1891. The wild days of the lumber era were winding down by the 1890s, and Harrison was starting to become a respectable city with law and order. Jim Carr and his common-law wife, Maggie Duncan, both died a year later in 1892, and most of the lumberjack crews had moved north.

Wagon tracks lead to the big Lumberman's Supply Warehouse of the WH&FA Wilson Lumber Company. Located at the intersection of First (US 27) and Second Streets, the building faces north. The boardwalk leads up to the livery stable for the Johnson House and the hotel itself. The *Clare Press* reported the Johnson House opened on May 24, 1880. The building still stands as the northern part of the Surrey House. The southern half and third story were added after 1900.

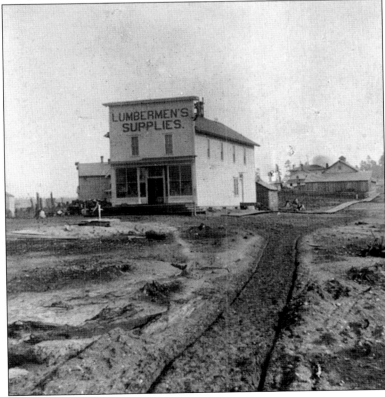

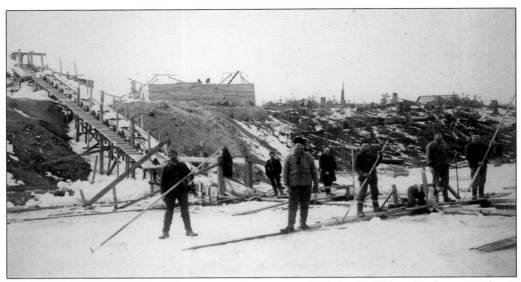

Shown under construction, two large ice warehouses were built by the Wilson brothers as Wilson's Ice Works that could hold 60,000 tons of ice. Depending on the weather and conditions, ice harvesting could pay better than lumbering. Trains from Michigan sent ice to Cincinnati, where it was then sent farther south.

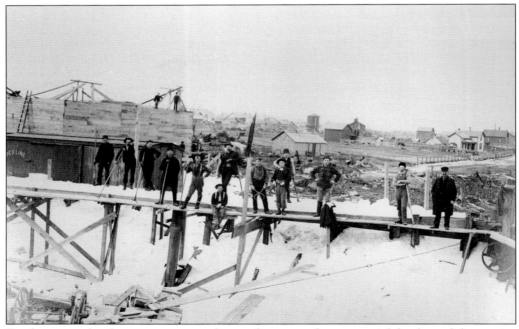

Sawdust was a burdensome waste product and a tremendous potential fire hazard, but an ice works acting in tandem with lumber mills made good business sense. Sawdust, a by-product of mill operations, was used for its insulating properties to pack ice for storage and shipping. Ice was cut from the lake, stored in icehouses, and later sold during the summer for a premium price. To the left in this image is the icehouse under construction. (CCHS.)

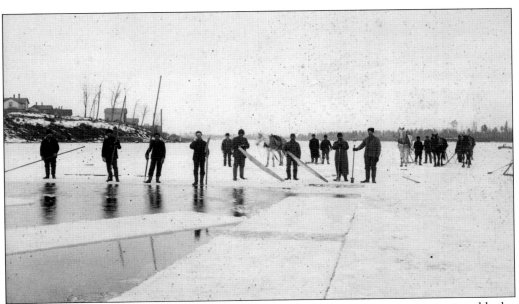

Lumberjacks often worked at the ice works using their huge crosscut saws to saw ice into blocks. The ice was sent up the mechanical slides and loaded onto the waiting trains or stored in the icehouses. Budd Lake's frozen assets were often sent to southern Michigan and Ohio. (Beemer.)

Solomon Mixter (left) was a foreman for Hackley Humes at a large lumber camp named Cole's Camps. He kept big teams of handsome Percheron horses. After the lumber industry moved on, the family moved into town, and Mixter used the teams to deliver and transport goods. He came to Harrison from Sanilac County but was born in Canada. The distinctive lettering on the bottom of the photograph is the style of photographer L.O. Moore.

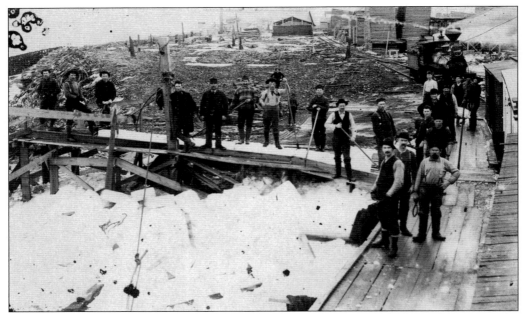

These men are at the top of the ice slide to the north of the mill, which can be seen in the background. It was unseasonably warm in Ohio and southern Michigan in 1890, and the ice did not get thick enough to harvest. The need for ice to be shipped south was so great that all the lumberjacks and teamsters in the surrounding woods were paid to turn their crosscut saws into ice-cutting tools. Historian Forrest Meek estimated 750,000 tons were shipped that year. Michigan's lumber industry paid better by far than the California Gold Rush, and Budd Lake's ice paid better than white pine in 1890. (Beemer.)

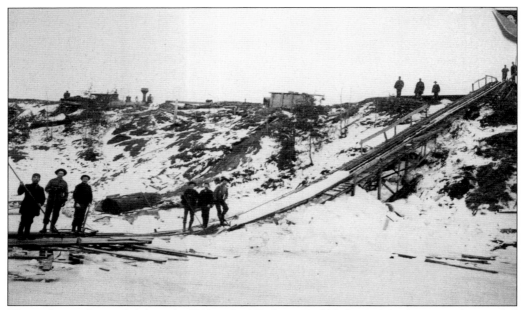

This is the mechanical slide at the Wilson Ice Works on Budd Lake. In March 1890, a disgruntled employee burned one of the large icehouses, and 20,000 tons of ice was lost. (Meek.)

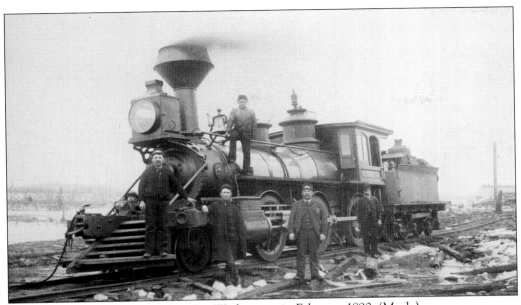

This is the train engine at Wilson Ice Works, seen in February 1890. (Meek.)

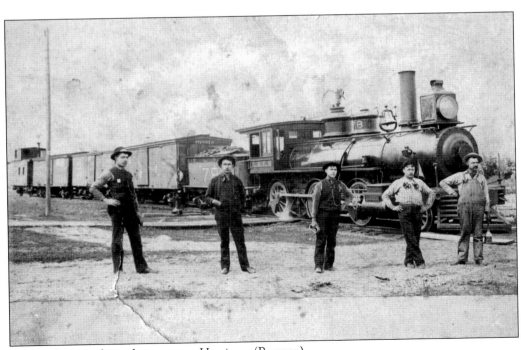

The mighty iron horse has come to Harrison. (Beemer.)

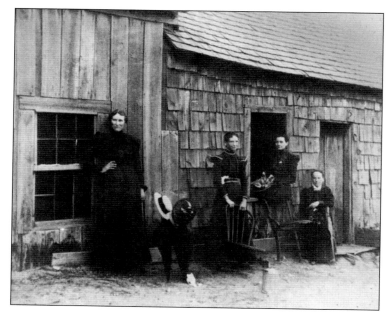

Often called "soiled doves," prostitutes were an inevitable factor of the lumbering era. Wherever there were thousands of shanty boys in the woods, there would be saloons and brothels, saloon keepers, and "ladies of the night" to take the hard-earned money that men of the lumber camps were eager to spend. The two-legged chairs demonstrate that while the ladies always offered a man a seat, they were not encouraged to lounge long. (Meek.)

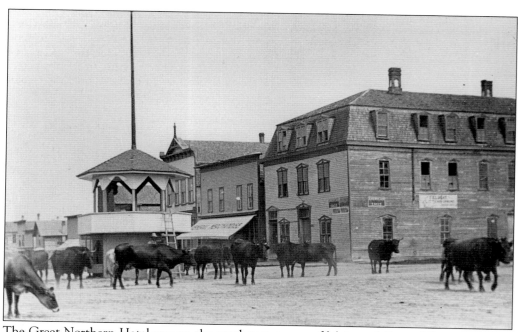

The Great Northern Hotel was on the southwest corner of Main and Second Streets and was owned by Bernard Heller. It was the largest hotel in Harrison at the time—and also one of the rowdiest as noted by the broken windowpanes on the second floor. The Hughes Brothers stores sit behind the right side of the bandstand. American Eagle signs advertise a brand of tobacco popular in the late 1800s.

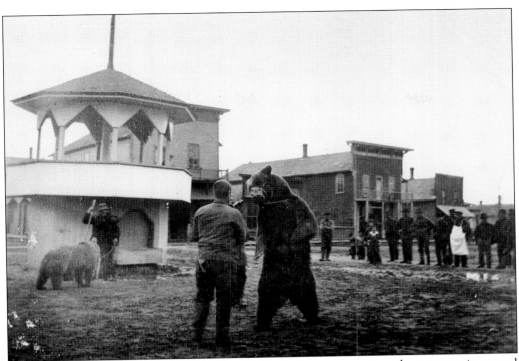

When Spikehorn Meyer was just a boy—long before he became a tourism phenomenon in central Michigan—grizzly bears appeared on Main Street and Second Street in downtown Harrison. Probably part of a traveling show or circus, this bear is wearing a muzzle but is exciting entertainment. The building in the background of this northeast-facing image is the library location today. The bandstand with four attached watering troughs sat in the city center on Main Street and Second Street. It was later moved to the City Park. The Harrison band provided music on Sundays and holidays from the bandstand both in the city and at the park. (CCHS.)

The Harrison Cornet band marches west on Main Street. Directed by Henry Heismann, the band represented the musical talent of the town. In the background, the finest homes on Lake Street were built by the Wilson brothers. The Wilson house (left) is without the second-story back addition that exists today.

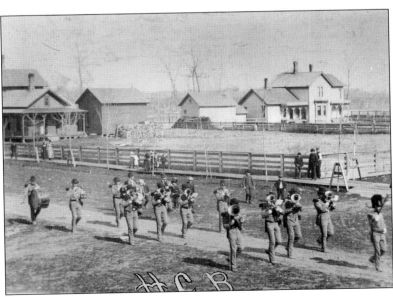

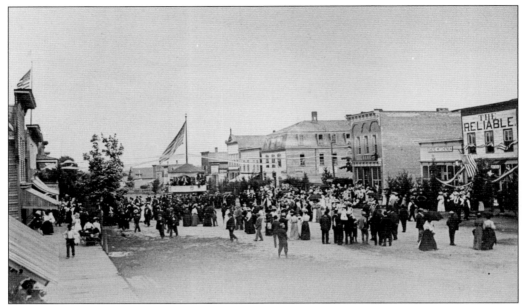

Note the wide boardwalks and the only brick structure: the bank. To the far left at the end of the block, Wilson's Opera House is the only building on the block that exists today. One Fourth of July celebration in Harrison was said to have lasted from July 3 to July 5, with continuous dancing and playing of the orchestra. (CCHS.)

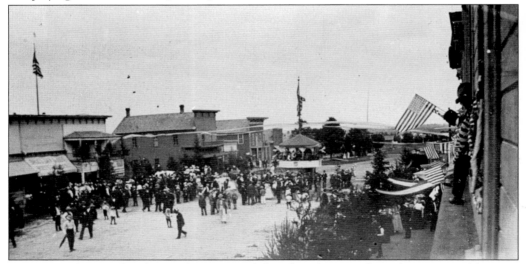

Harrison is decorated with trees, banners, and flags for a festive Independence Day celebration. The 45-star flag (right) dates this celebration to sometime after 1896. The view is from near the current location of the *Clare County Cleaver* office and looks toward the intersection of Main and Second Streets. The *Clare Press* reported in 1887 that $8,250 in tax was collected where liquor was sold. Clare had six saloons, which paid $1,800 in tax; Farwell, one saloon, which paid $300 in tax; Harrison, 15 saloons, which paid $3,900 in tax; and Meredith, which paid $2,250 in tax. Harrison's earlier notorious reputation of having 22 saloons was rivaled only by Meredith in the mid-1880s and, several years later, by Seney in the Upper Peninsula. In 1884, Jim Carr paid $600 in liquor tax, double of what was paid by any other saloon owner in the county. (CCHS.)

Two

VILLAGE

PEACEFUL NOW

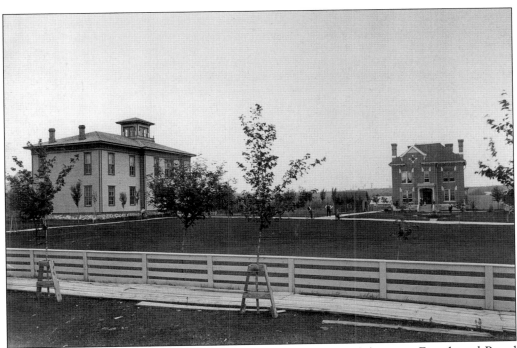

The county courthouse construction began in 1879 on the block between Fourth and Broad Streets. The redbrick jail trimmed in white sits to the right, and a steam plant to heat all the buildings is located in the background. To the left stands the courthouse, a two-story structure overlooking a spacious and well-kept lawn. A round fountain, 12 feet in diameter, with shrubbery and maple trees for future shade, made the complex impressive. This is a view from Broad Street looking west.

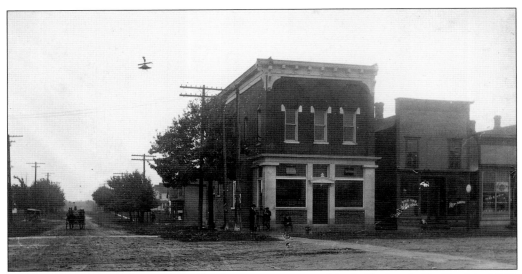

The State Savings Bank was created by the reorganization of the L. Saviers & Co. Bank in 1906. Its original officers were some of the most prominent citizens in Harrison: Lemuel Saviers, Andrew S. McIntyre, Nathaniel White, W. Henry Wilson, Fred W. Weatherhead, Ellis G. Hughes, Elmer J Hughes, and Charles R. Giddings.

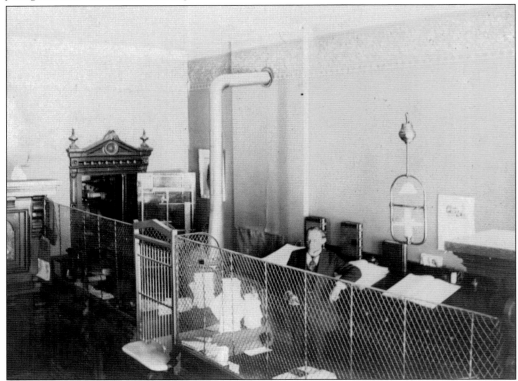

This is Fred Weatherhead at his post as cashier inside the L. Saviers & Co. Bank. Weatherhead was a community leader who loved to ice skate, which he did on the lake well into his 80s. He was a longtime member of the Congregational church choir and often sang at funeral services.

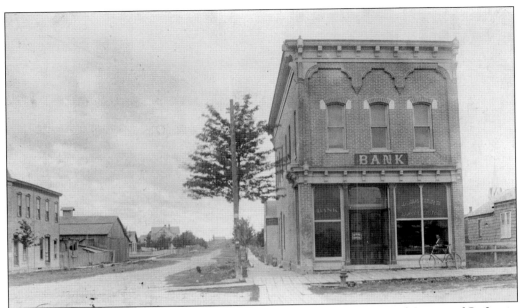

The first bank in Harrison, L. Saviers & Co. Bank was founded by Lemuel Saviers of St. Louis, Michigan. It later reorganized as the State Savings Bank of Harrison. The second bank in Harrison, People's Bank of M. Fanning & Co., later merged with the State Savings Bank. Fred Weatherhead, pictured in the window, was associated with the bank until his death at 92 years of age. (Beemer.)

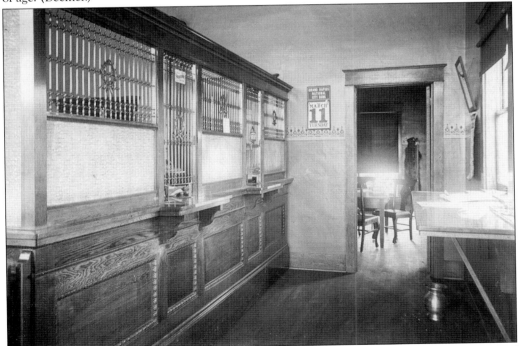

This is a photograph of the interior of the State Savings Bank in the early 1900s. It was one of the few remaining historical buildings in Harrison when it was torn down in the 1970s.

This is an early view of the courthouse, with sheriff John Brown and prosecuting attorney John Quinn out front with a group of people posing for the camera. Funds were not provided to build a jail, for a cost of $3,000, until 1885, possibly a political maneuver to protest the moving of the county seat to Harrison. Until that time, prisoners were taken to Midland, Osceola, and Isabella Counties for detention. This contributed to the lawlessness and reluctance of the sheriff to make arrests. The Catholic church sits behind the courthouse (left). (Beemer.)

The original Catholic church on Broad Street was built in 1900. A newer church erected in 1987 sits near the same location to the south on the corners of Spruce, Broad, and Fourth Streets.

The Methodist Episcopal Church was located on Oak Street. This same structure later housed the United Brethren Church until a new building was constructed on East Main Street in 1953. The First Baptist Church was also located on Oak Street, pictured here.

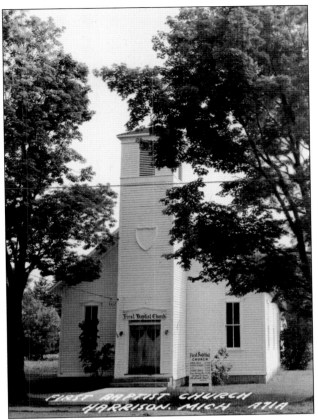

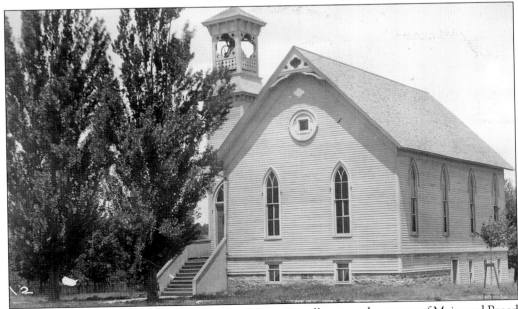

The Congregational church, built in 1885 or 1886, originally sat on the corner of Main and Broad Streets. In 1965, a new edifice was built on the south corner of Spruce and Fourth Streets.

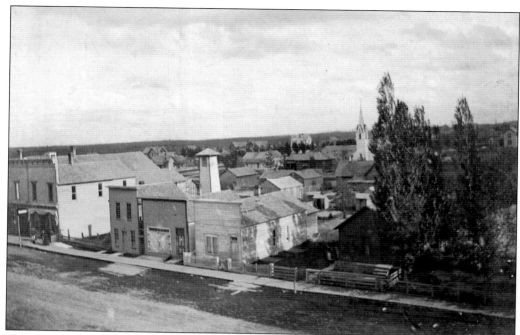

This is a southeast view from the bell tower of the Congregational church. Harrison's first fire station is in the left center with the tower that would have enclosed the siren, referred to as "the mockingbird." The Baptist church steeple rises behind it on Oak Street. The office of the *Clare County Cleaver* is on the far left with "Cleaver Office" lettered on the top of the building. Its current location is most likely the small home to the right, where it moved after a fire in 1925. The newspaper, which dates to 1881, is Harrison's longest-running business. (Beemer.)

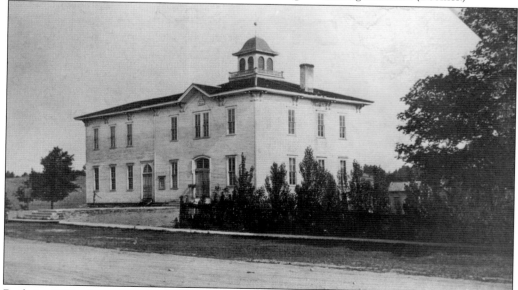

Built in 1881, the original school was 35 feet by 35 feet. The west side (left) of the school was added later. It was called the Hayes Agriculture School throughout the early part of the century. (Beemer.)

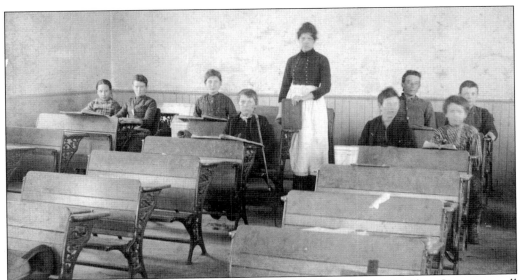

Until the 1940s, the one-room school was a basic educational institution in Clare County as well as in the rest of rural America. Eventually, consolidation with neighboring school districts started for a number of reasons, including the improvement of roads and vehicles that made traveling greater distances possible. Much of the district was consolidated by 1950. Giving up the school was a wrenching experience for most neighborhoods. This is Bailey School in Hayes Township in 1887. Kitty McGarry (far left) and Charles Bailey (far right, background) would later marry. Their teacher is Etta Wilson. The one-armed boy (far right, foreground) is Fred Bailey. (Beemer.)

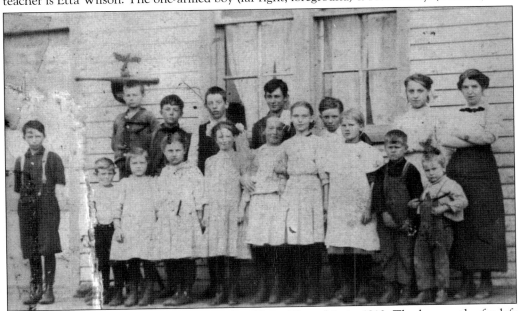

Pictured are students of the Bailey School in Hayes Township in 1910. The boy on the far left is Carl Bailey. Also seen are, from left to right, (first row) Floyd Brooks, Helen (Carolyn) Bailey, Carrie Bailey, Lila Brooks, Ella Bailey, Violet Morrows, Frances Beemer, Arthur Beemer, and Charles Bailey; (second row) George Bailey, Bill Young, Fred Bailey, Charles Young, Louie Brooks, Fern Munsell, and teacher Gladys Darling. (Beemer.)

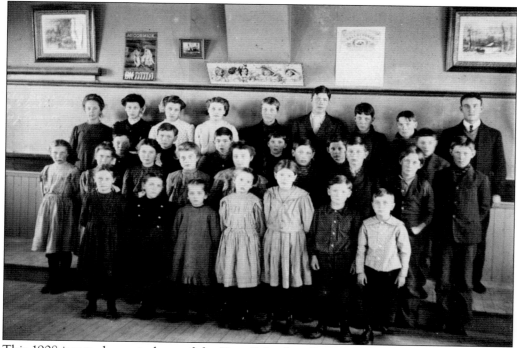

This 1908 image shows students of the Doty School in Greenwood Township District No. 3. From left to right are (first row) Lottie Bruce, Leta Budd, Ella VanValkenburg, Clara Bruce, Vina Sprague, Bill Payne, and Averill Budd; (second row) Lilah Bruce, Keith Vosburgh, Erma Sprague, Frieda Graub, Flora Payne, Stanley Bruce, and Tom Bruce; (third row) Fred Starkey, Elijah Payne, Paul Gleason, Ira VanValkenburg, Albert Bruce, and Louis Vosburgh; (fourth row) Ina VanValkenburg, Nettie Doty, Anna Bruce, Nita Sprague, Chauncey Woodin, D.C. Sprague, Lawrence Dart, Horace Payne, and teacher Leo J. Trainor. (Beemer.)

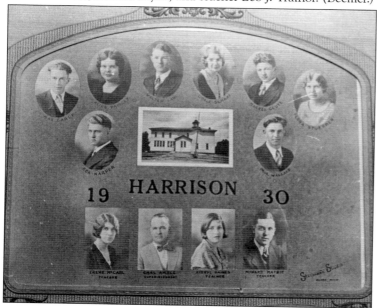

The graduating class of 1930 included, from left to right, (top row) Max Carly, Alice Paisley, Walter Lang, Odale Schaaf, Morrel Clute, and Flora Stuermer; (second row) Rex Harper and Paul Wallace. The staff members on the bottom row are, from left to right, teacher Irene McCarl, superintendent Charles Amble, teacher Averyl Gaines, and teacher Mynard Maybie.

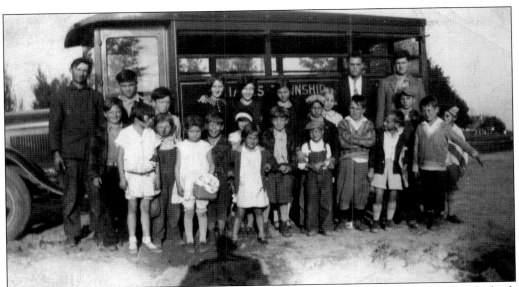

This is the Hayes Township school bus in 1930. To the left is driver Floyd Craine, and in the back row, third from the left, is Nada Stockwell Sharp. (Courtesy of the Bond family.)

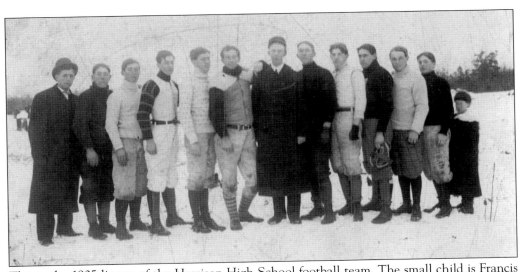

This is the 1905 lineup of the Harrison High School football team. The small child is Francis "McKinley" Browne, the team mascot and brother of Henry (sixth from right). Their father, William Henri Browne, was a prominent lawyer, early Clare County commissioner, county treasurer, justice of the peace, and school principal. McKinley would later own "Heritage Hill" on the east side of Budd Lake, property that was land granted to the Browne family. (Beemer.)

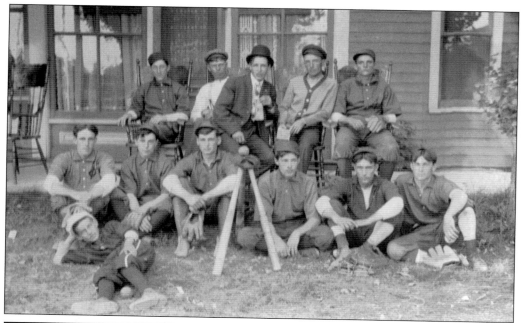

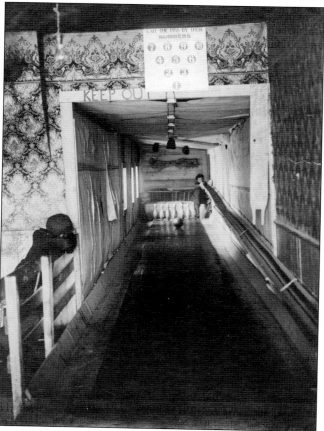

This is the baseball team, pictured around 1905 in front of the Lewis home on Beech and First Streets. The child in front is mascot Phil Gosine. The home is also said to have been the location of this bowling alley in 1912. (Beemer.)

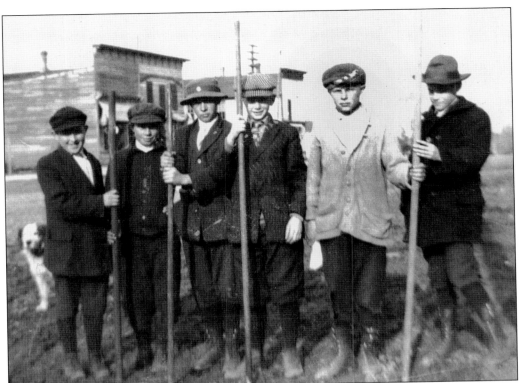

Harrison's first Boy Scout troop is pictured on quail patrol on Main Street around 1913. From left to right are Harold Smith, Floyd Scott, Lewis Light, Charles Morrissey, Stanley Mitchell, and Paul Weatherhead. (Courtesy of the LaValle family.)

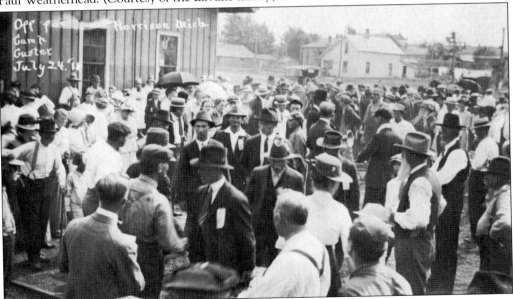

On July 24, 1918, young men and many townsfolk gather at the Harrison train depot to see men heading off to Camp Custer by train near the end of World War I. (Beemer.)

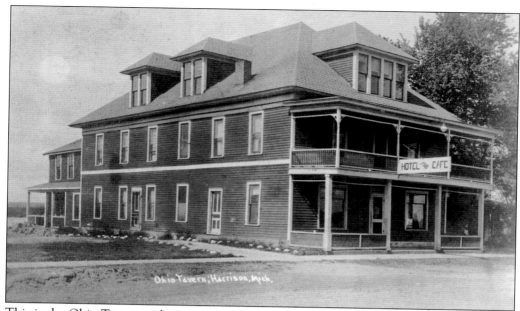

This is the Ohio Tavern with its entrance facing south on Beech Street (instead of the west-facing entrance of today). Formerly the Lockwood House and before that the Johnson House, it was known throughout the late 20th century first as the Colonial House and then as the Surrey House. Receipts found within the walls from the lumber era indicate its wild past and frequent glass replacement. No hotel in Harrison remained a house of temperance by the end of the wild heyday of lumbering.

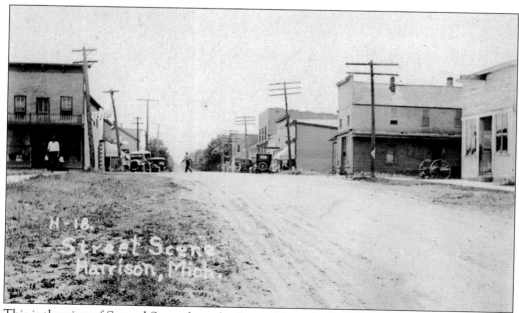

This is the view of Second Street from the Surrey House looking south. The federal post office is on the right. In the 1930s, the city built its office building and fire hall across the street from the Surrey House.

While no records can be found of Dean's Hotel, a Charles Dean owned a restaurant in Harrison in its early years. Proprietors of this hotel, family cottage, or restaurant certainly had a sense of humor. Many business establishments came and went quickly based on the fortunes of their owners, fire, or shifts in the dollars that lumbering generated in its path.

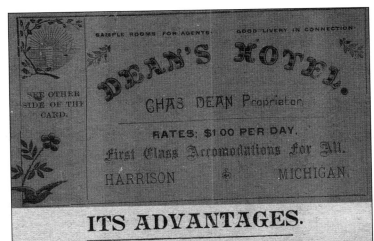

SAMPLE ROOMS FOR AGENTS.　　GOOD LIVERY IN CONNECTION.

DEAN'S HOTEL.

SEE OTHER SIDE OF THE CARD.

CHAS DEAN Proprietor

RATES: $1 00 PER DAY.

First Class Accomodations For All.

HARRISON　　✦　　MICHIGAN.

ITS ADVANTAGES.

This hotel is equipped with all the modern conveniences of the age, provided, especially, by this house for the public.

If the guests do not approve of the location of the house, it will, on application to the landlord, be removed nearer the depot, or to any other desirable location, P. D. Q.

All guests have corner front rooms, up one flight only, with seaside view and latest improved fire escape attachments.

Sewing machine, gas, daily papers, fire alarm, telegraph, bath, hot and cold water, grand piano, water closet and all other modern conviences in each room.

Each guest furnished with coupe, laundry, restaurant, elevator facilities best seat in dining hall and best waiter.

Warm meals at all hours and hence no second table.

If guests are offended by the waiters, clerk, "slush" or any of the other assistants, report to the landlord, and they will be immediately fired from the mouth of a cannon on the piazza in front of the hotel.

For further particulars see Bill of Fare.

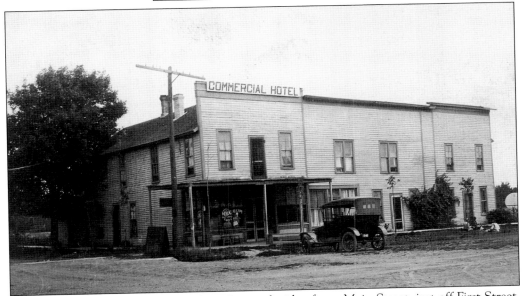

The Commercial Hotel was located on the north side of east Main Street, just off First Street. The Commercial would often serve as a makeshift hospital, reserving a room or two for patients who would then be seen by a doctor in town. This was a common practice before the advent of hospitals.

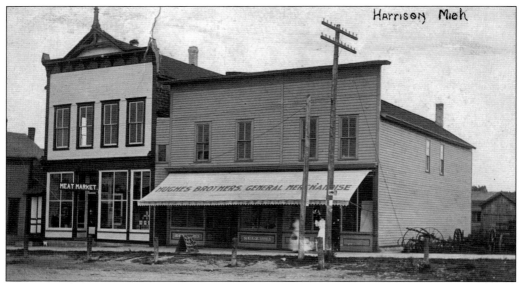

These are two storefronts of the Hughes Brothers store. One side held a general and dry goods store, and the other was a meat market and grocery; the two connected on the interior.

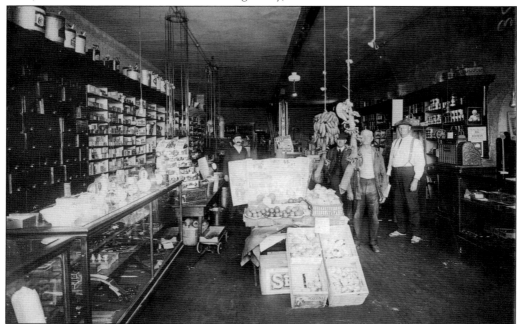

Hughes Brothers General store, owned by identical twins Ellis and Elmer Hughes, opened in the former Silverstein Building in 1891. The brothers were later joined and aided in business by a cousin's husband, Johnny Brown, during the Great Depression when business began to fall apart as the town's population declined. Shown here in its heyday, it was a true general store, selling anything anyone could ever need. Brown was a bona fide intellectual as well as a teacher, traveler, and widower. He was enthusiastic about the challenge the store presented. Ellis Hughes was the buyer, collector, and bookkeeper. Elmer was the salesman who was always pleasant, sociable, and positive. (Courtesy of Hughes family.)

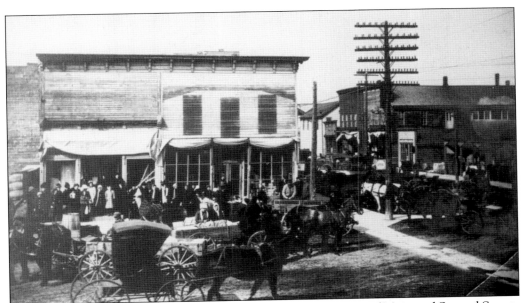

Michael Fanning built a dry goods and grocery store on the corner of Main and Second Streets downtown and later added a drugstore. A third store built on the block stored and sold caskets. Later, Fanning's son Bryan bought a home on Beech Street and operated a funeral home there until he sold the business to Frank Coker of Farwell in 1965. This is a view of Fannings in 1910. (Meek.)

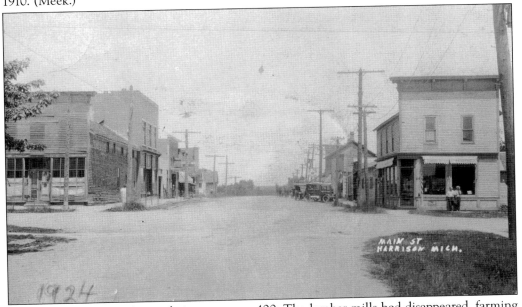

By the 1920s, Harrison's population was near 400. The lumber mills had disappeared, farming was not prosperous, and people drifted away with no sustainable livelihood. The town had no economic base, and the buildings were aging and in disrepair. The transition from horse-and-buggy days to the automobile industry was a difficult one for Harrison. Soon, the automobile and tourism would change the town. In this view of Second Street looking north, the former Fanning Store is on the left, and the current location of the library is on the right.

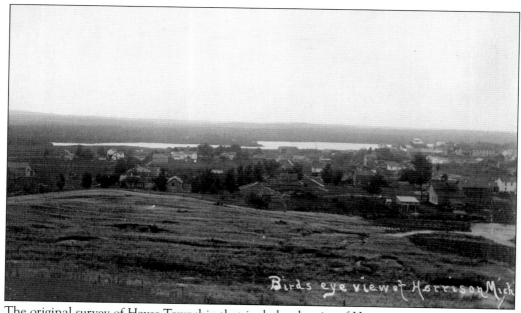

Birds eye view of Harrison Mich

The original survey of Hayes Township that includes the city of Harrison was made by George Adair and his party, who covered the area on horseback and with packhorses. Clare County was created in 1840 but not officially organized until 1871. It was originally called KayKaKee after a Sauk Indian chief, but a few years it later renamed Clare, supposedly by an Irish surveyor after his native County Clare in Ireland.

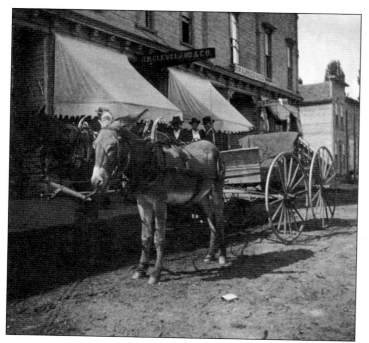

This is a farm wagon in downtown Harrison on Main Street in front of the post office and *Cleaver* office. Unfortunately, only a few remaining buildings survive from the lumber era. Structures were not replaced with permanent brick structures when they burned or needed repairs. A handful of homes, one hotel/restaurant, and a few now indistinguishable buildings remain. (Beemer.)

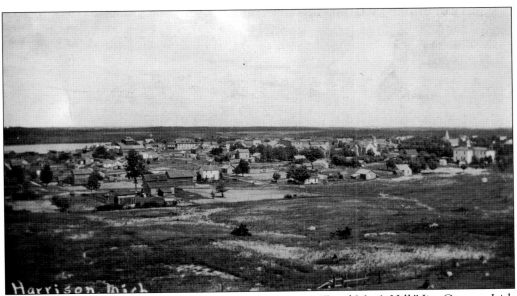

This is an early view of Harrison from what was known as "Dead Man's Hill." Jim Carr, an Irish lumberjack from the Farwell area, set up his saloon, dance hall, and brothel with his common-law wife, Maggie Duncan. His business was boldly placed just outside the village limits but in sight of the new county courthouse. They trafficked in every vice and robbed hundreds of lumberjacks, and some were never seen again after a visit to Carr's. In 1885, Carr was convicted and sentenced to 15 years in Jackson Prison for beating one of his girls at his second saloon in Meredith. After a year, the Michigan Supreme Court granted him a new trial, and Carr was set free.

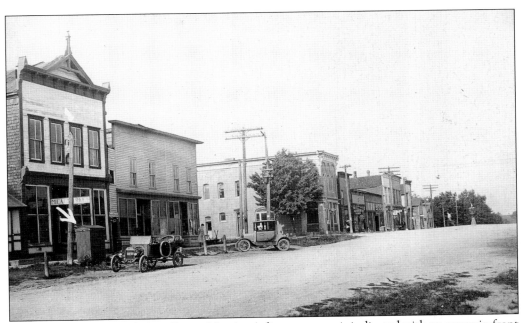

In this westward view of Main Street, Harrison's first gas pump is indicated with an arrow in front of the Hughes Brothers store. State Savings Bank is in the center.

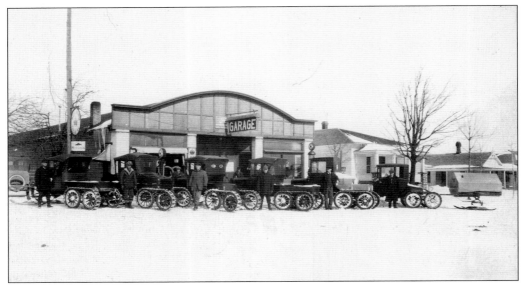

Above, mail carriers are shown at Hampton's Ford Garage in the late 1910s with aftermarket snowmobile kits for the Model T installed at the garage. In line from left to right are Jesse Allen, Bob Brown, Clyde Pifer, Miles "Doc" Darling, George Dillingback, and Bernie Hampton. The trailer (right) was a winter camper, and Bernie Hampton sought out remote winter fishing spots. The garage still stands in Harrison today, and the Ford emblem is still ghostly visible on the east side of the building. Below, the mail-delivery truck of rural letter carrier Jesse Allen shows the Model T-to-snowmobile conversion. It took a mechanic to mount the unit and a powerful man to steer it. The altered automobiles had truck rear axles and gears in addition to lightweight steel caterpillar treads and cumbersome wooden runners shod with steel. Pure glycerin was used in the radiator; it had to be drained when the machine was not in use since it congealed in cold weather. The snowmobiles could go where even a horse could not, and the local doctor sometimes kept the rural carriers on call for emergencies.

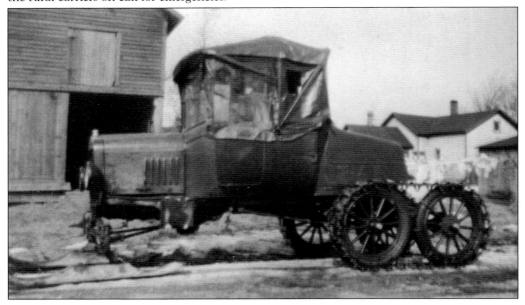

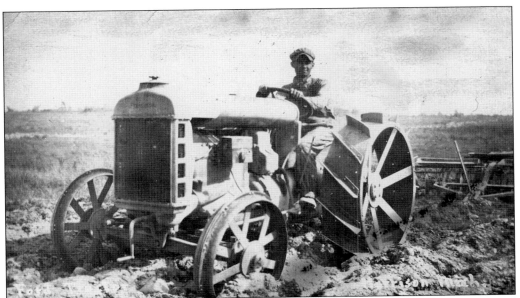

Henry Ford took an interest in agriculture and bought 1,600 acres of cutover land in Greenwood Township in 1911. Between 10,000 and 15,000 stumps remained on the property that had to be cleared before it could be farmed. Fordson tractors and a few horses farmed wheat, oats, corn, hay, and potatoes. H. Leigh Mixer of Harrison was part of the local labor force on the farm.

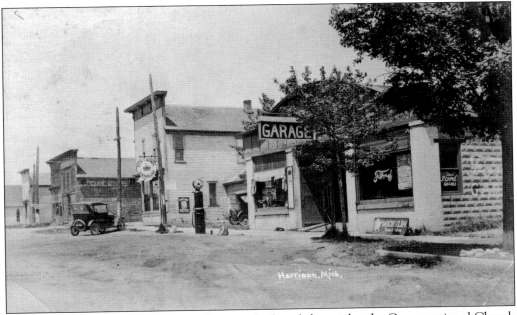

This is a view looking west on Main Street with, from left to right, the Congregational Church (cropped), unknown, Fanning's Grocery on the corner of Main and Second Streets, the Budd Lake Inn (current library location), and the Ford Garage. If one looks closely at the east side of the building, the words Ford Garage can still be seen today. (Courtesy of John Brandon.)

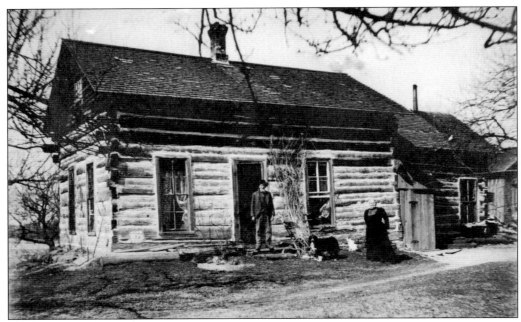

The Hayes Township homestead of Joseph and Mary Saunders was land granted to Joseph in 1879. Born in England in 1841, Joseph Saunders was a typical immigrant who fought in the Civil War and later made his way to Michigan as a homesteader. Many newcomers to the area bought or acquired their land sight unseen and were likely disappointed in the condition when they arrived. In the *Detroit Free Press*, University of Michigan professor Filbert Roth called Clare County land in the early 1900s "cut-over pine land sand barrens." (CCHS.)

The Sam Fraser farm, located just west of Harrison, was likely the location of the second poor farm in Clare County in the 1890s. The first was in Grant Township, and the farm shown here was in Hayes Township. It was sold as a private farm, and the new infirmary opened in 1912.

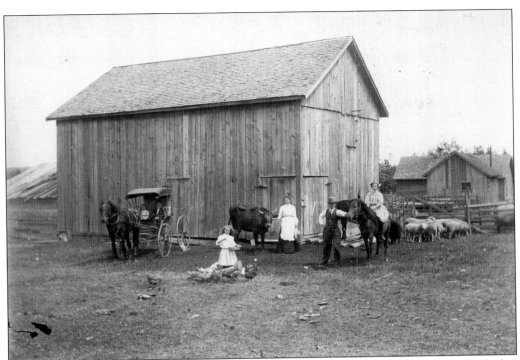

An early homestead near Harrison represents those who lived on farms but probably worked at other professions for their main income. (Beemer.)

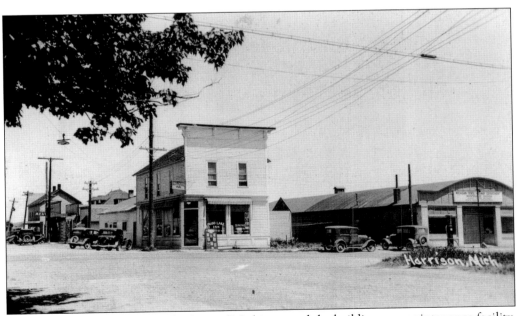

After the Ford Garage closed, the State of Michigan used the building as a maintenance facility. This photograph was taken in the 1920s. (Beemer.)

John Joos, a German-born butcher and widower, lived here with his daughter Edna and niece Anna. Joos was a capital investor in the newly reorganized State Savings Bank. This home was located on Main Street next to the Ford Garage.

This is the Young home on Main Street in 1900. Sitting on porch is Homer Ellsworth. Algernon Sidney Young, justice of the peace and postmaster, stands beside his wife, Elizabeth Young, who is sitting.

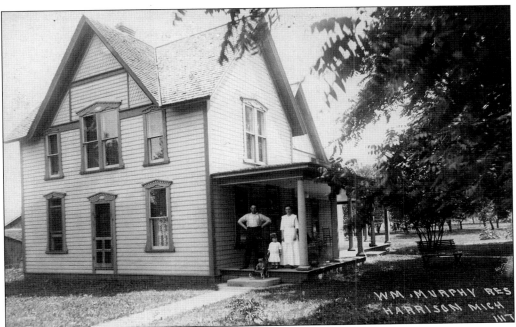

The William Murphy home was located at the corner of First Street and Oak Street. Murphy was a local grocer, druggist, and mortician.

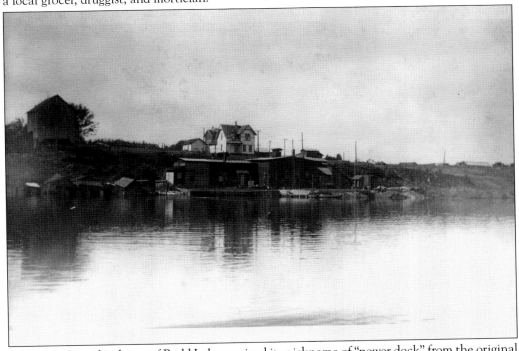

Saxton Park on the shores of Budd Lake received its nickname of "power dock" from the original power station located there. Pumps and wells for water hydrants for fire and other city services were housed there, and electricity was generated by steam power for the town before services were delivered by larger power companies.

This is the home of Farwell A. Wilson; it was one of the first built in Harrison. Pictured from left to right in front of the house are Florence A. Wilson and her twin brother; Ann W. Wilson, wife of Farwell; Farwell A. Wilson; Earl F. Wilson; Phalle Corrigan (Wilson); and possibly Avila Rice and Ester Hoover (Brown), sisters of Ann W. Wilson. The girl in the doorway may be Susie Rice holding Lea Corrigan, and Mercy Miller, sister of Farwell. The man on the far right is unidentified.

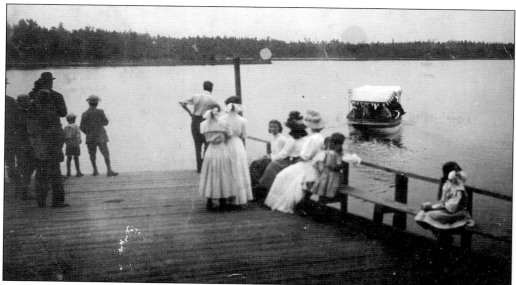

Here, the Wilson family is enjoying a day on the lake. The dock is just south of the location of the Saxton Park today. It would have been in front of the large homes the Wilson brothers built on the lake in the 1880s.

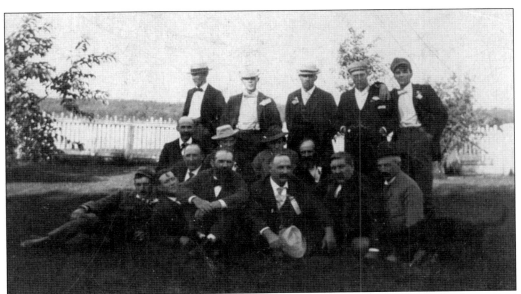

These are two photographs from the Wilson family reunion at Budd Lake in 1895. The women pictured below are, from left to right, (first row) unidentified, Margaret Richardson Potter, Cora Wilson Johnstone, unidentified, and Zora Richardson Heisman; (second row) two unidentified ladies, Mrs. S.F. Wilson, Charlotte Wallis Richardson (Charlotte Wallis Richardson), unidentified, and Mrs. W.H. Wilson. (Beemer.)

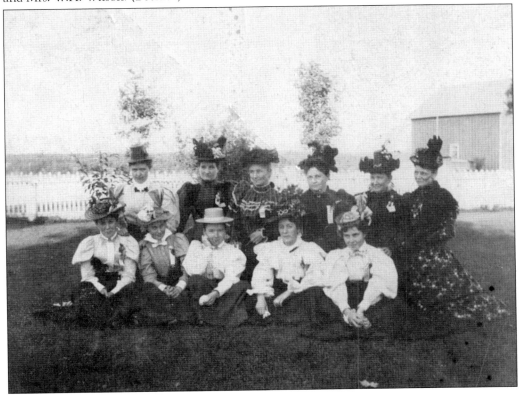

This is a beautiful spot on Budd Lake, one of the many landlocked sources of water abundant in Clare County. Clare County—from Farwell to Meredith, with Harrison in the epicenter—sits on the natural division of streams and rivers much like the continental divide in the Western United States that separates the waters flowing east and west. Between the directionally different flowing waters sits Harrison, with the vast stands of white pine timber and no water sources to move it. Logging railroads would eventually cover Clare County, and the county would have more miles of rail than any county in Michigan and possibly the entire United States for a short time. (Beemer.)

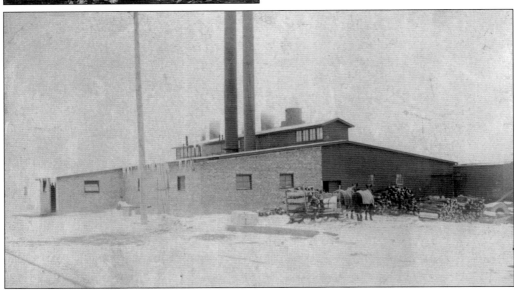

By the 1890s, big timber was gone, but there were ample stumps, leftover log piles, and a few trees for the heading mill to employ men to make barrelheads. Only one partner, F.A. Wilson, remained in Harrison. His brother William Hotchkiss Wilson and cousin William Henry Wilson left the area, and the company was bankrupt by 1896. W.H. and another brother, Earl Wilson, started the Michigan Land Company, headquartered out of Flint.

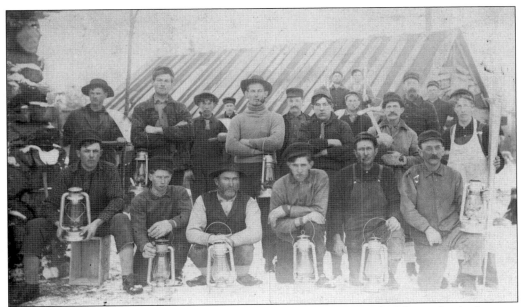

The night crew at Wilson's heading mill poses with an important tool of the trade, the lantern. These are most likely local workers, as the transient jacks had moved on by the early 1900s. Jim Graves is in the back center with the cap and handlebar mustache. (Beemer.)

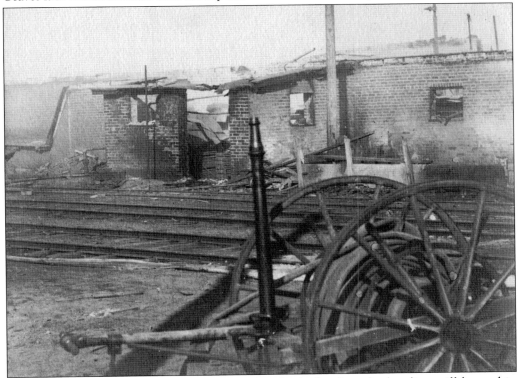

The fire equipment in the foreground proved to be futile when the heading mill burned in 1908. (Beemer.)

The pleasure of your company is requested at a

Hallowe'en Party

to be held at

Wilson's Opera House, Tuesday Eve, Oct. 31, '99.

Music by Butts' full orchestra with piano accompaniment.

Program will consist of waltzes and all latest dances.

Good Order Guaranteed. Bill 50 cents. Refreshments Served.

COME AND GIVE US
ONE MORE CHANCE *Frank Pervorse, Manager.*

This is from the scrapbook of Clarabelle (Mixter) Titus. In the 1960s, Titus wrote articles for the *Clare County Cleaver* from her home in Florida. Her recollections in a column called "Now . . . I Recall" were from the earliest days of Harrison when her father worked in lumber camps and farmed until lumbering moved on and the family relocated into town.

Shelter Tent No. 131,
K. O. T. M.
HARRISON, MICHIGAN.
"Merry Christmas," 1891.

Built in 1884, the Opera House hosted stock entertainment touring companies. In 1890, a second story was added, along with a stage, dressing rooms, a balcony, a ticket office, a coat-check room, and a dance floor. The building was used for basketball games, talent shows, formal banquets, ballroom dances, and other community events. It was said that it seated 700. It had a raised stage with a beautiful scenery curtain, and on the arch over the stage was the motto, "All the world's a stage and all the people actors." The building is still in use today as the Harrison Masonic Temple. (Beemer.)

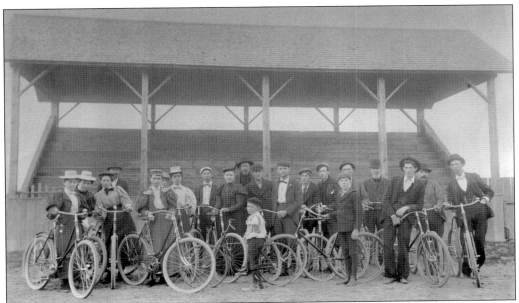

This is the Harrison Bicycle Club at the fairgrounds in the 1890s. The transition from tough lumber town to peaceful village was already under way. Local pastimes changed from drunken rowdiness to bicycling dandies in their Sunday finery. Riders would trek out to Greenwood, the men in plus fours and the women in bloomers. Fred Weatherhead is front and center, wearing a tie, and his wife, Mary Hughes Weatherhead, is fifth from the left. Steve Morrissey stands to the far right. (Beemer.)

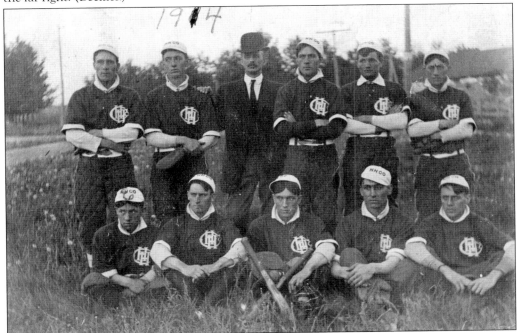

This image shows the 1914 baseball team in the city of Harrison. Many communities had city teams not affiliated with school teams.

The Weatherhead family lived in this home on Pine Street. Fred and Mary (Hughes) Weatherhead raised two children, Nettie and Paul. Fred was a banker and a real estate developer. Paul Hughes Weatherhead, a well-traveled teacher, resided here until his death in 1989. Nettie died while accompanying her husband to the Philippines, where he was a teacher.

Fred Weatherhead, born in Livingston County, was a banker and prominent citizen of Harrison all of his long life. He died in 1952 after serving 60 years in banking, first with the L. Saviers Bank & Co. and then the State Savings Bank. (CCHS.)

This is a train ticket of Mary Hughes, sister of the Hughes brothers and future wife of Fred Weatherhead. Mary was the first and only graduate in 1887 but participated in the graduation ceremony in 1888. Mann's was a lumber-era town and then a small settlement south of Harrison with a railroad siding owned by a Mr. Mann and a cluster of homes. Today, the area is known by the name of the road, Mannsiding, and there is no trace of the settlement. (CCHS.)

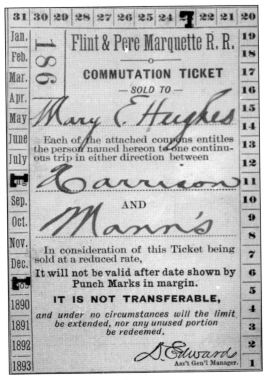

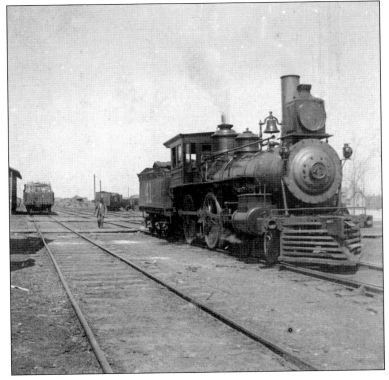

This is the train at Harrison with Wilson's Mill in the background. Train service continued to Harrison until the rails were pulled up in 1944. The Flint & Pere Marquette Railroad was chartered on January 22, 1857, for the purpose of constructing an east-west railway line on a route, for which a federal land grant was offered, from Flint to Pere Marquette (now Ludington). (Beemer.)

Al Crigier, Clare County sheriff (left), is pictured in 1924 with bank and FBI officials along with Fred Weatherhead (right) next to a recovered safe found in the woods near Muskegon after Harrison's only bank robbery. The culprits were never apprehended.

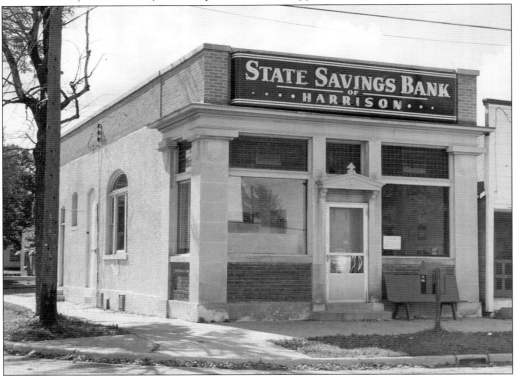

The State Savings Bank remained in operation in Harrison until it moved; the building was torn down in the 1970s. The second story was removed in 1948, and a new roof was installed.

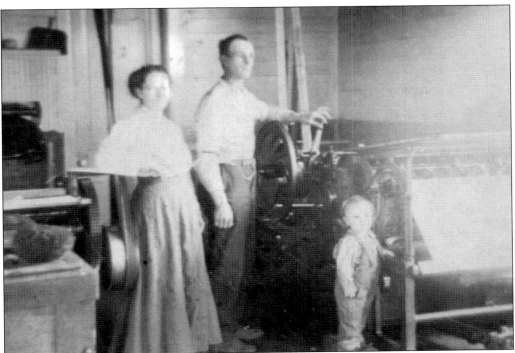

Publisher Jesse Allen, his wife, Martha, and son George pose in the pressroom of the *Clare County Cleaver* in 1909. The paper was handset from movable type at that time. It was started in 1881 by John Quinn and John Canfield in the back room of a butcher shop, and a cleaver—the tool of a butcher—was cleverly used as its name. Asa Aldrich acquired the paper from Quinn, who later sold it to Jesse Allen. The *Cleaver* was taken over by Emil Bucholz in June 1937, and it is still operated by the family today.

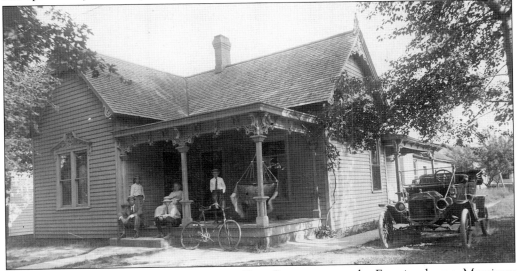

The residence of Francis Morrissey was on Pine Street next to the Fanning home. Morrissey served as Clare County clerk for almost 25 years and was on the draft board during World War I. He was highly respected in the county and was universally well liked.

This c. 1908 photograph showing Townline Lake Road around the north end of Budd Lake was made into a popular postcard. Wagon tracks through the sand illustrate the condition of early roads. Fred Weatherhead stands in the foreground.

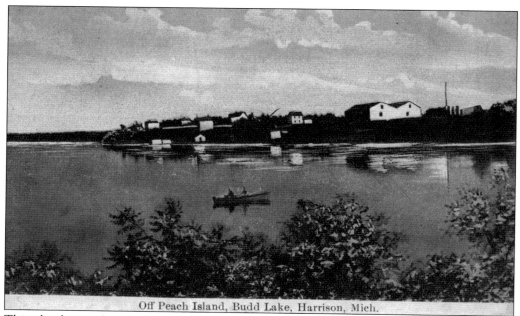

Off Peach Island, Budd Lake, Harrison, Mich.

This island was referred to as "Peach Island" for a short time after 1887 when brothers W.H. and F.A. Wilson cleared the land for a peach orchard. The plans to plants trees on the shores of Budd Lake did not come to fruition because of the failure of the Peach Island orchard.

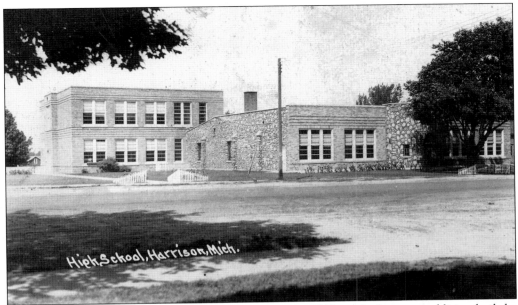

The Harrison Community School is shown here in the 1930s with the stone addition built by the Works Progress Administration. It was later torn down.

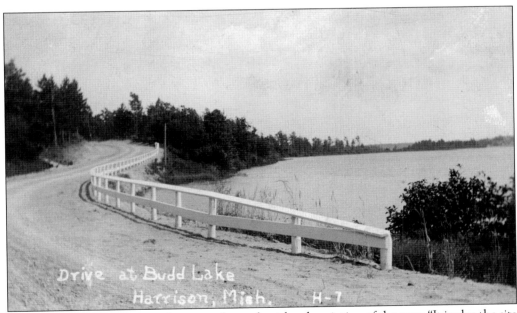

An early-1900s advertisement lures people north with a description of the area: "It is also the site of the famous Budd Lake Mineral Springs and ozone laden air, both famed the country over for their curative qualities. . . . Recently a summer resort has been platted on the east shore of Budd Lake, and it is known as Harrison Heights Summer Resort." Townline Lake Road is seen curving around the north end of Budd Lake.

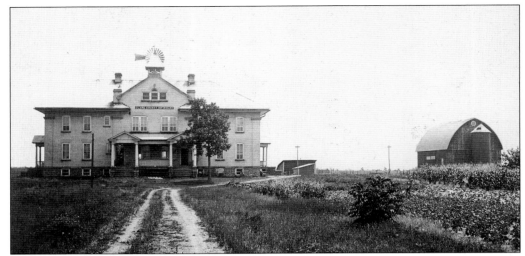

The Clare County Infirmary, pictured around 1912, was located on County Farm Road. The new facility had dropped the "poor farm" title to give occupants a little more dignity, though the name was commonly used. The caretaker family lived in the center, with a wing for men situated on the south and one for women on the north. Residents raised their own produce and domestic farm animals.

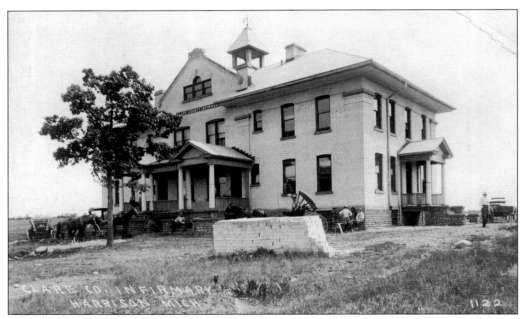

This was the third location for a poor farm in Clare County. The first poor farm was in Section 35 of Grant Township, and the second was on 160 acres in Section 20 of Hayes Township. The Harrison location was settled on after much debate and political maneuvering by local political forces. Many believed it should be near the county seat. Clare County supervisors organizing the new poor farm were Adams, Alwood, Bailey, Boulton, William Browne, Bruce, Cross, Emerson, Gordon, Howard, Jackson, Jennings, Ladd, McKenna, Quinn, Rought, Asa Rowe, Dan Rowe, Slater, Tryon, David Ward, Week, and Finch.

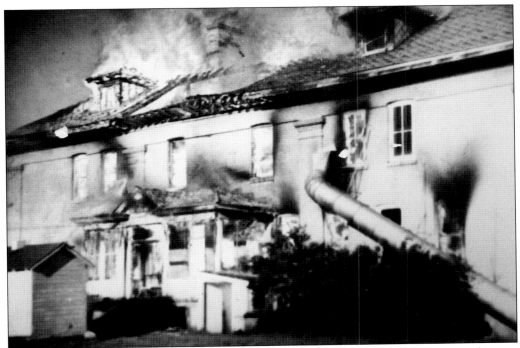

The infirmary closed in 1945. It is shown here on fire in 1948. The cause of the blaze was unknown. The building was used as a meeting place for the Harrison Veterans of Foreign Wars Post 1075 and Auxiliary after the infirmary closed.

After the 1916 Federal Road Aid Act, the county began to get serious about its road infrastructure. Automobiles were becoming popular with farmers, and there was an increased demand for better roads. Pictured here is a surveyor crew in the late teens. Miles Darling stands second from the right.

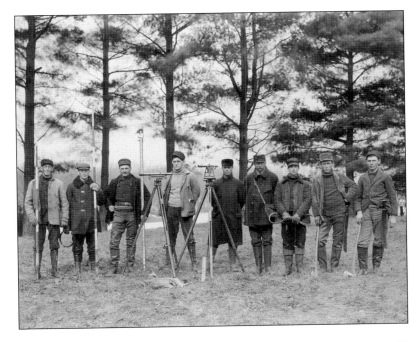

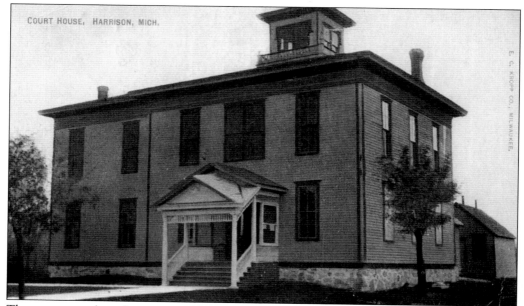

The county seat brought money to Harrison. Extra business generated by the courthouse and jail was the difference between profit and loss for the stores, hotels, saloons, livery stables, and other lines of business during the early days. Elected officials, county employees, and lawyers accounted for 20 households in the new town. Many more stayed temporarily when court was in session. In lean years during the Depression, holding the county seat likely saved Harrison from the same fate that doomed many Michigan lumber towns after the timber was gone and nothing else was left to fall back on—becoming a ghost town. (Beemer.)

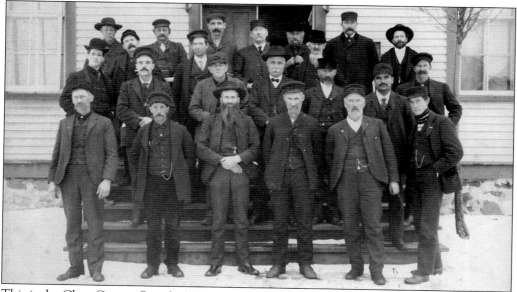

This is the Clare County Board of Supervisors in 1904. An elected official from each township and city in the county made up the board until the 1960s, when Michigan's state constitution changed and counties were redistricted by population for representation. Now, instead of over 20 supervisors, there are seven county commissioners.

The courthouse and jail complex included a steam plant to heat all the buildings and a small red barn. The barn was used to house the sheriff's livestock. It also served to impound livestock caught running loose; fees were charged in these instances, which helped support the running of the barn. (Beemer.)

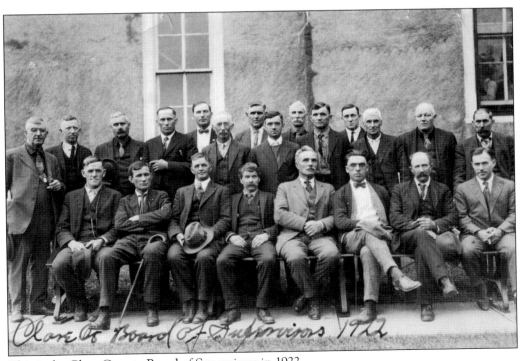

This is the Clare County Board of Supervisors in 1922.

James Carr was the second inmate in the new jail that was built in 1885. He passed away in 1892, most likely from a combination of alcoholism and hard living. His fortune was spent, and the heyday of lumbering in Clare County was winding down. Maggie passed away shortly after him. The two undoubtedly were the most infamous characters to haunt Harrison's past, and they still intrigue history enthusiasts today with the many mysteries that surrounded their lives.

The jail was badly needed to bring law and order to Harrison. Having no jail, the sheriff was reluctant to arrest anyone. Permission and funds from the supervisors to transport prisoners to Midland or other counties was hard come by. The *Clare County Press* reported that Jim Carr himself ran for justice of the peace in April 1886 and received one vote; whether his own or Maggie Duncan's, just a single vote was cast in his favor. His saloon was positioned on a hill in view of the courthouse. For a time, he may have thought himself to be—and may actually have been—above the law. Carr's saloon was just outside of the village limits and beyond village authorities.

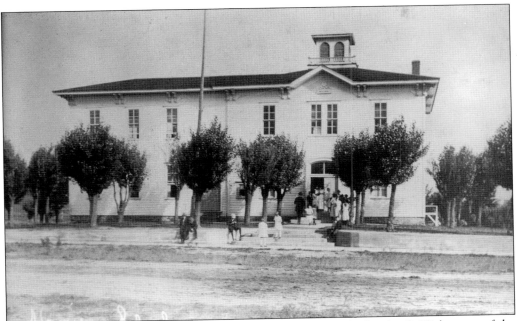

Many students of the new school would board in town to go to high school. With many of the one-room neighborhood schoolhouses still teaching kindergarten through eighth grade, it was the older pupils who commuted to town or boarded over. Eighth graders were tested by state standards to enter high school or to legally quit school.

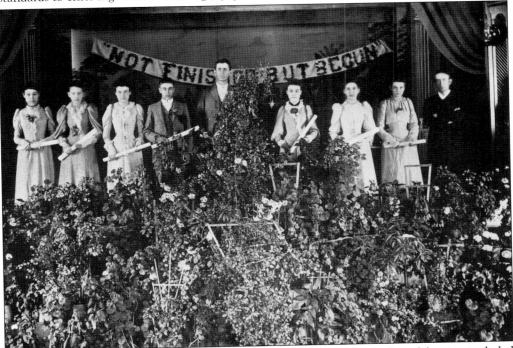

This is the 1892 graduating class of Harrison at Wilson's Opera House. The celebration included beautiful potted plants, including rose bushes, gracing the stage. (Beemer.)

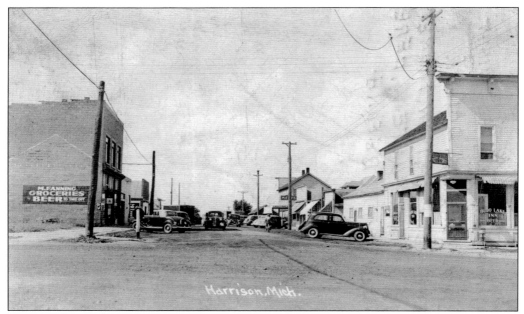

Harrison during the Depression was just starting to make a comeback from its near–ghost town status. This is Second Street looking north. The Fanning store (left) remains as one downtown building instead of three. The outline of the old store can still be seen on the building. The Budd Lake Inn (right) serves the now quiet town as a much tamer restaurant and saloon. (Beemer.)

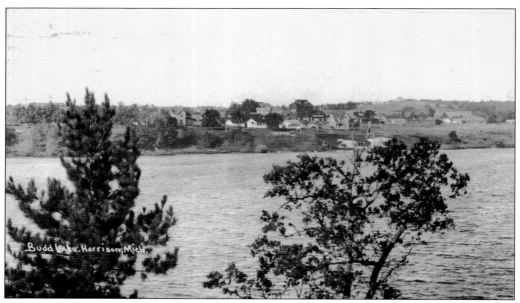

This is a view of Budd Lake and Harrison from the east side of the lake. The Harrison Elevator can be seen as well as the nice homes along Lake Street.

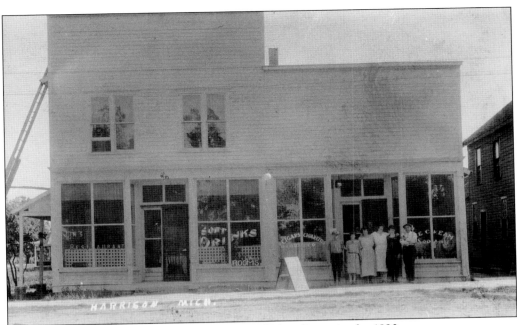

Here is downtown Harrison on the south side of Main Street in the 1930s.

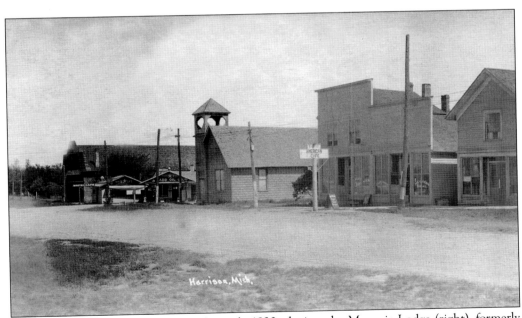

This rare image of Main Street in the early 1920s depicts the Masonic Lodge (right), formerly the Wilson Opera House. The church (center) proves the long-standing rumor that the bar at the main intersection of Harrison was a house of worship. Originally the location of the Saginaw Saloon, this church is partially the same building today as the Budd Lake Bar & Restaurant. The other buildings pictured are small restaurants and cafés. (Courtesy of John C. Brandon.)

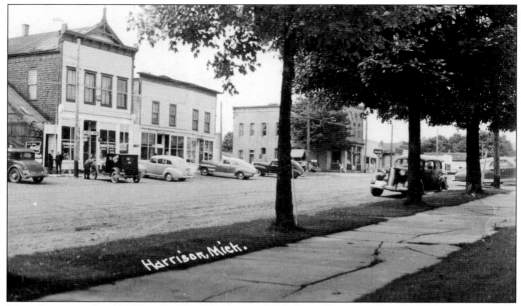

Main Street in the 1940s is seen here bouncing back from the Depression. While the roads are still dirt through parts of town, Harrison is beginning to prosper as a tourism destination.

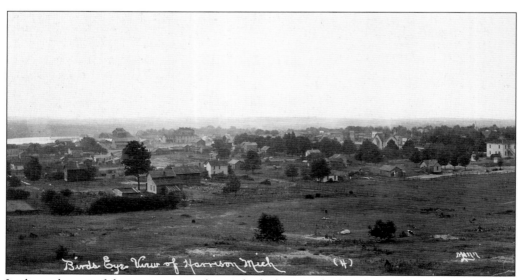

In the early part of the century, most homes had a barn or shed in the yard for horses, cows, and chickens. The animals were taken care of mostly by children. Some would be taken to Lockwood's pasture, now the location of the high school football field.

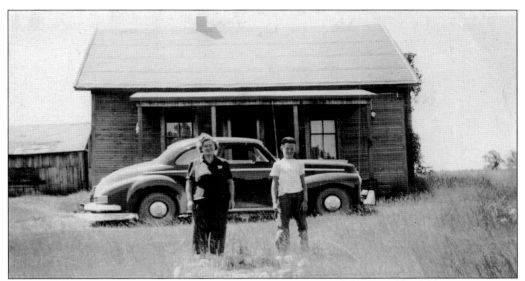

Daisy Lewis and Duane Beemer pose in the mid-1940s in front of the house built by the Civilian Conservation Corps on the corner of Towline Lake and VanDuesen Roads. (Beemer.)

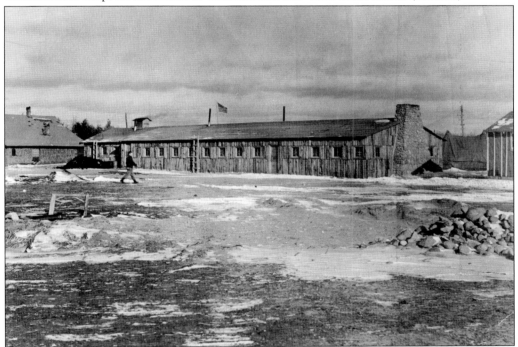

Part of Roosevelt's New Deal, the Civilian Conservation Corps (CCC) saved many families from starvation and taught young men a sense of moral integrity along with skilled trades. The camps ended with the onset of World War II, when those same young men were sent overseas to fight and become America's "greatest generation." The camp was east of Harrison and worked on many local roads and built structures at Wilson State Park that are still enjoyed today. The CCC crew built a bathhouse with showers, basins, and a water tower on the north shore of Little Long Lake. (Courtesy of the Forest History Society, Durham, North Carolina.)

No. 31 Incorporated Under the Laws of Michigan Shares Three

Long Lake Farmers' Telephone Company
Frost Township, Clare County, Michigan

This Certifies That _Mr. Frank Cramer_

is the Owner of _Three_ _____ Shares of the Capital Stock of the

Long Lake Farmer's Telephone Company

Seal

Transferable only on the books of the Corporation by the holder hereof in person or by Attorney upon the surrender of this Certificate properly endorsed.

In Witness Whereof the said Corporation has caused this Certificate to be signed by its duly authorized officers and sealed with the seal of the Corporation this _Third_

day of _May_ _____ A. D. 19_18_

James C Bailey Shares $10.00 _Chas Koch_
President each Secretary

Here is capital stock of Long Lake Farmer's Telephone Company in 1918. At the end of 1919, the company had six subscribers and 18 miles of wire. The company was out of business by the 1920s. (Beemer.)

Harrison, Mich.

With many trees growing tall and the stumps of the lumber era rotting, lost, or pulled, the quiet hills northwest of Harrison offer a serene view of a small, peaceful city.

Three

Tourism

"20 Lakes in 20 Minutes"

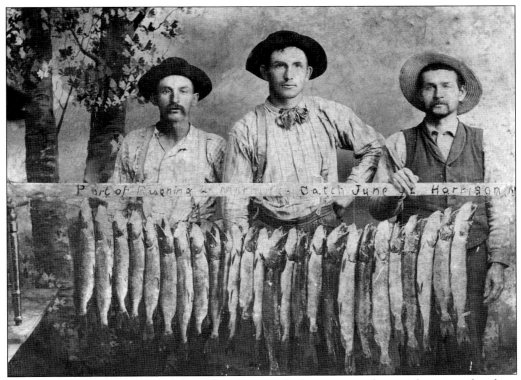

In the 1890s, Oliver Gosine (right) and friends enjoyed what many residents and tourists after them would return to the area for: its superb fishing, hunting, and outdoor recreation. (Beemer.)

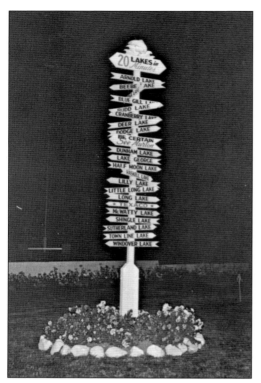

With over 90 lakes nearby (but 20 within a 20-minute-or-less drive), the area has always boasted with the sign, "20 lakes in 20 minutes" in the center of Harrison. This original sign was made by Thelma Hubbell and sponsored by Murton Oil Co. A similar sign still stands in Harrison, directing vacationers to central Michigan's best lakes.

This photograph shows young men on Budd Lake at a location known today as Saxton Park. Two of the men who can be identified are Fred Bailey (second from left) and Ernest Merrill (center, left of pole). (Beemer.)

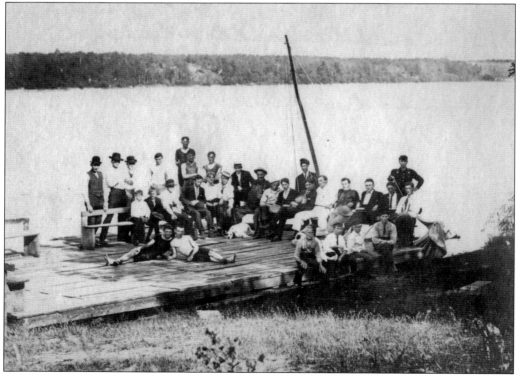

This is a view of the east side of Budd Lake from the west. The route led to the seasonal blueberry fields in northern Clare County and southern Roscommon County. It also led to fishing sites on Houghton and Higgins Lakes, always popular since pre-European times. The Indian Trace from Isabella County to Houghton Lake ran along the western shore of Budd Lake. While there were no permanent Native American settlements along the lake, the Trace, also called the Isabella Trail, led many settlers through the region, and many modern roads follow the same path.

This is the drive known as Lover's Lane at Wilson State Park. The Wilson brothers donated 35 acres of land on Budd Lake to the Village of Harrison in 1889 for a park. Later, the city would hand over care of the park to the State of Michigan in the early 1920s, and today it is the beautiful and popular Wilson State Park.

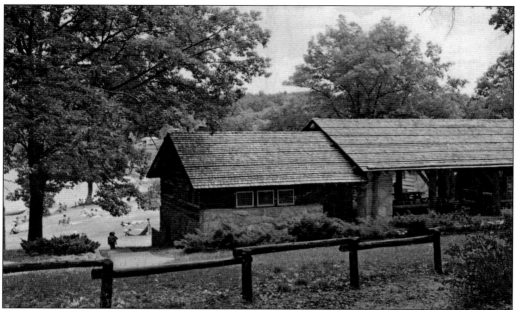

This is the bathhouse at Wilson State Park. In the 1950s and 1960s, the snack bar was contracted out to provide snacks and meals to beachgoers. The bathhouse and rental cottage at the park entrance were built by the Civilian Conservation Corps from 1939 to 1941.

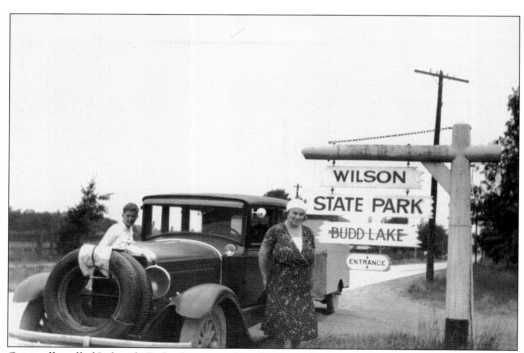

Originally called Lakeside Park when owned by the City of Harrison, the park's name was changed to Wilson Sate Park when the State of Michigan assumed ownership. An early entrance to the park is shown here along US Highway 27. (Courtesy of Joe Bradley.)

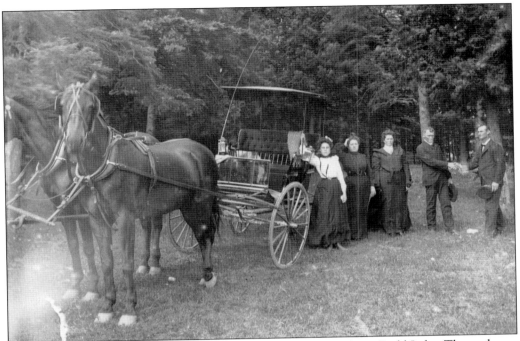

This photograph shows Mr. and Mrs. Fred Petit at Lakeside Park on Budd Lake. The park was a popular place for weddings, reunions, and other events. Water carnivals were held annually after the turn of the century, and swimming competitions included Olympic swimmers and drew crowds of over 10,000 to the park. (Beemer.)

Here is a later view of the entrance to Wilson State Park in the 1960s.

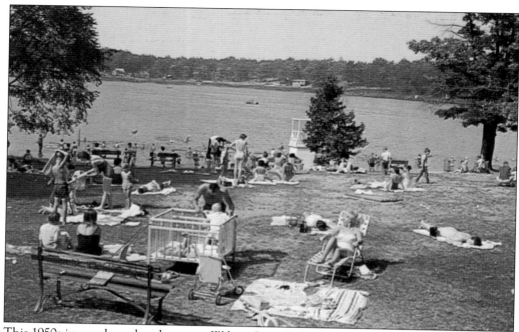

This 1950s image shows beachgoers at Wilson State Park.

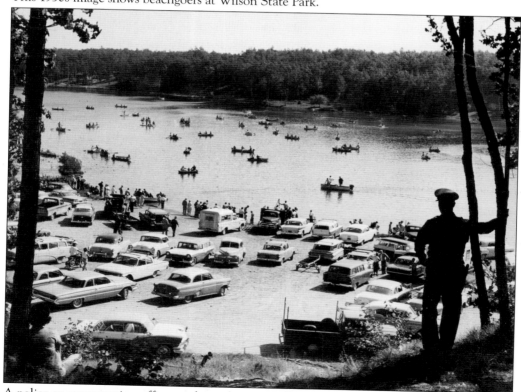

A police or conservation officer makes a dramatic silhouette amongst the boats coming in and out of one of the famed "20 lakes within 20 minutes."

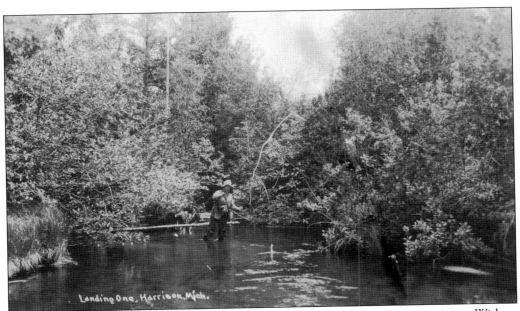

The location labeled "Landing One" on this postcard has been lost to recent memory. With so many lakes, ponds, and streams, the area has always been popular with fishermen. (Beemer.)

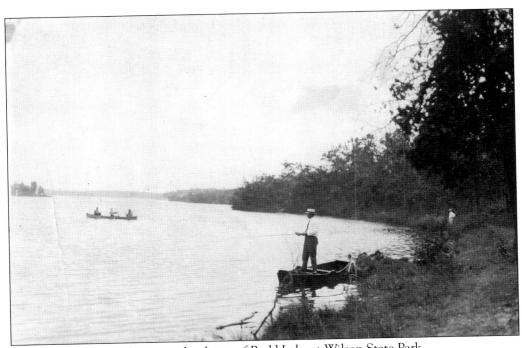

Fred Weatherhead is shown on the shores of Budd Lake at Wilson State Park.

Popular as seasonal cabins in the early tourist years, "wooden tents" like this one housed summer tourists getting away from the cities of southern Michigan. Named Trails End by its part-time residents, it sat on Hughes Point in the city of Harrison and was later remodeled into a year-round home. Five prefabricated cabins on Hughes Point have all now been replaced with beautiful lakeside homes. (Courtesy of Roger Westburg.)

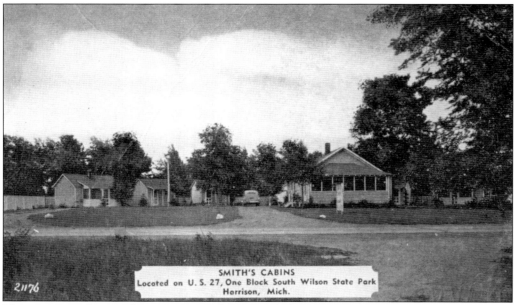

SMITH'S CABINS
Located on U. S. 27, One Block South Wilson State Park
Harrison, Mich.

Many tourist cabins and camps sprouted up around the Harrison area. Fred Smith claimed his cabins in Harrison were "located in one of the Michigan's health spots recommended for hay fever and asthma. Good Fishing and Hunting. High altitude." Now the location of McDonald's in the heart of Harrison, his cabins were just south of the state park. Harrison boasted "20 lakes in 20 minutes," and many cabins were located on the numerous lakes and waterways in the area.

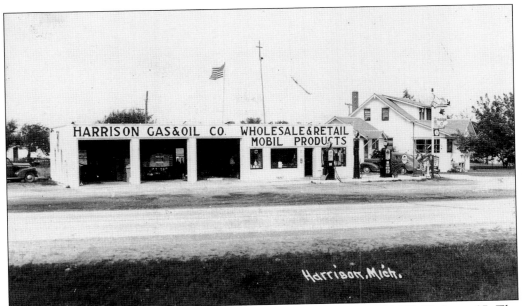

Harrison Gas & Oil, shown here in the 1930s, was located on Old US Highway 27. The service station, which is still used as a garage, and the home on the right look relatively unchanged today.

The son of Fred Weatherhead, Paul Weatherhead and his wife, Edith, owned Weatherhead's Cabins and sporting-goods business. Paul was a schoolteacher and spent years teaching around Wayne County, Michigan, and in the Philippines.

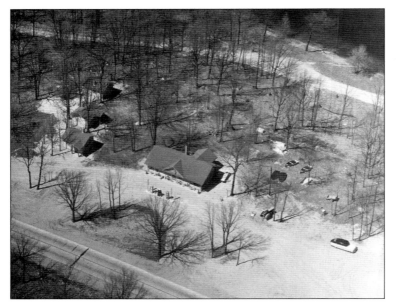

This is an aerial view of the combination Weatherhead's Cabins and the sporting-goods and real estate business between Budd Lake (top right) and US Highway 27 (bottom left.) The business has been known as Lakeside Motel and Cottages for over 50 years.

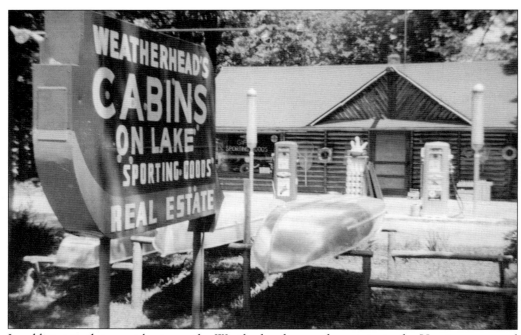

In addition to the resort business, the Weatherheads owned property in the Harrison area and sold real estate. They sold a large piece of property on Budd Lake to real estate developer James A. D'Arcy. The property was platted into the Weatherhead-Hughes subdivision and included all the lake lots north and south from Hughes Point. D'Arcy developed the unique idea of selling cabins and lots as a package deal. The affordable, ready-made vacation getaway between $495 and $795 was marketed to factory workers in the Detroit area. D'Arcy also developed the Snowsnake Mountain Ski Resort.

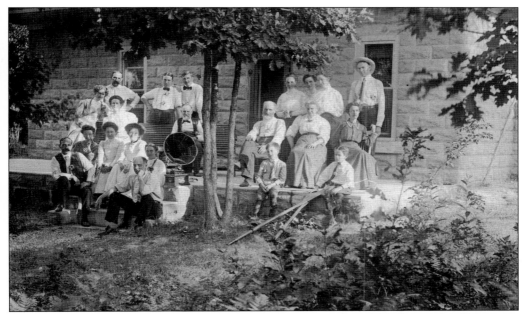

The prominent Weatherhead family also kept a cottage on Arnold Lake north of Harrison, which they named "U-Need-a-Rest." The extended family is shown here gathered on the porch at the cottage. Their affluence is evident by the phonograph pictured here and the large number of photographs in their family collection. Fred Weatherhead sits in the left center on the lowest step. His brother-in-law, Elmer Hughes, stands at the top on the far left, and Elmer's twin, Ellis, is seated at the lower far left.

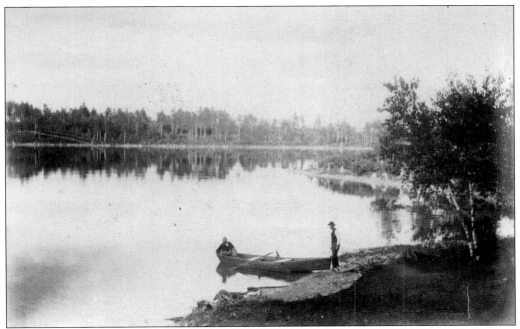

The peaceful, 188-acre Arnold Lake is popular for tourists and sportsmen. Today, it is the location of some of the area's most beautiful homes and cabins. (Beemer.)

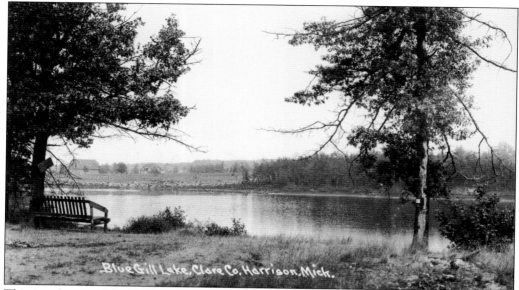

This is a farm on Blue Gill Lake, north of Harrison near Long Lake. There was a one-room schoolhouse in the Blue Gill Lake area. (CCHS.)

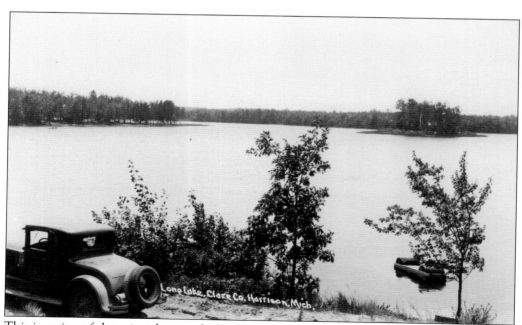

This is a view of the privately owned island on Long Lake. The barrel raft in the bottom right corner is a creative early effort to enjoy recreation on the lake. (Courtesy of Joe Bradley.)

This is C.A. Cotron's Long Lake Store, one of the many gas stations and county stores that served the growing popularity of travel by automobile. A rural post office named Long Lake operated from June 20, 1899, until May 15, 1912.

An early road along Long Lake presented a challenge for automobiles. Some of the branches of the railroad were turned into county roads that still exist today, while some became overgrown and were lost. This grade-turned-road near Long Lake is used today and is known as East Long Lake Road. (Courtesy of Joe Bradley.)

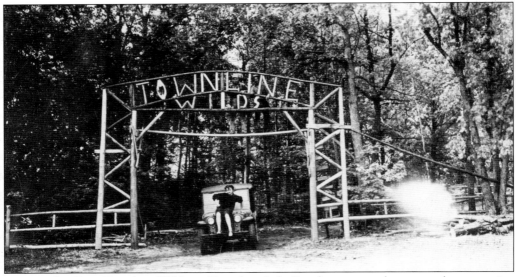

Near Dodge City, Townline Wilds on Townline Lake Road was a popular seasonal community. This photograph was taken in the 1950s or 1960s. (Courtesy of the Merton Bailey family.)

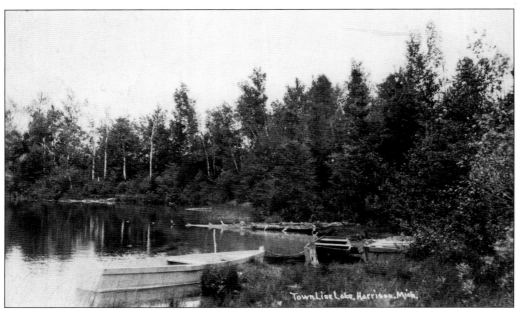

Here is the north shore of Townline Lake. Today, this same location is a popular dock for boats of area residents. (Beemer.)

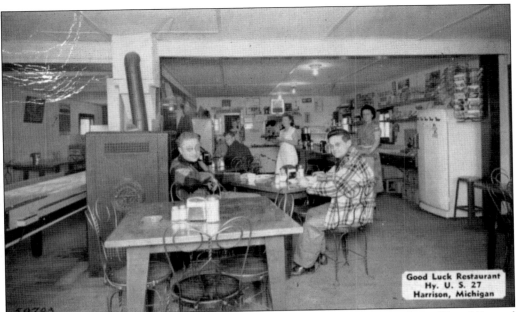

This is the interior of the Good Luck Restaurant in the early 1950s at US Highway 27 and Second Street. Owned by Pauline and Chuck Watts, it served beer and wine and specialized in home cooking and baking.

Greenwood Grocery, on the northeast corner of M-61 and Harding Avenue, was owned by the VanValkenburg and Peyton families. The country store was an important aspect of country life until the automobile made transportation to town easier.

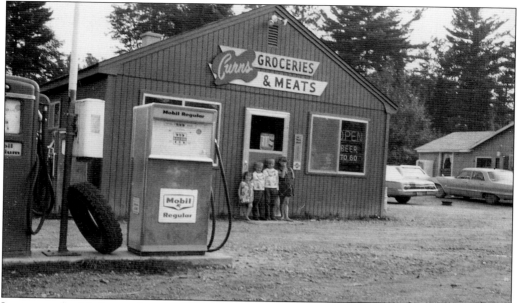

Leota, on the Muskegon River, was named after the daughter of A.E. Rhodes, who owned the nearby land. Lumber dragged or sent by rail to Leota traveled down the Muskegon River to the west side of the state until the extension from Harrison allowed lumber to be moved by rail to Harrison and on to Saginaw and Bay City. Curns grocery store, shown here, is still a gas station and corner convenience store today.

These are typical tourist cabins near Harrison in the 1920s. Over the years, these rental and seasonal cabins with their ideal lake locations have been enlarged, improved, and turned into year-round homes. The population of Harrison swells by the thousands during the summer months and the fall hunting season.

This shows Parkview Tourist Court across the street from Wilson State Park on the corner of US Highway 27 and Townline Lake Road. It has now been the location of the flea market for many years.

In 1940, the first home was built in Meredith after it had been a ghost town for many years. Constructed by Merrill and Myrtle Hoard, the cabin still stands today. After the lumbering years were over, what did not burn was hauled away and used for homes and farms, leaving Meredith deserted. (Courtesy of the Leposky family.)

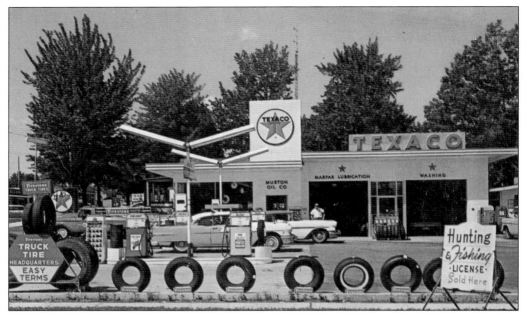

The Texaco station on the corner of Main and First Streets is now Old US Highway 27. This image was taken in the 1960s. The station was owned by Dave and Sue Murton of Harrison. Local artist Thelma Hubbell was a longtime fixture at the station, and the Harrison Community Library was her home away from home for many years. She created many charming children's displays in addition to building a puppet theater, dioramas, and a miniature of Harrison as it was in 1891, among other wonderful works of art. (CCHS.)

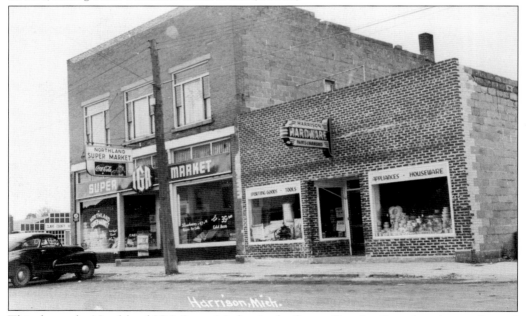

This shows the Northland IGA Super Market in the former Fanning Store location on Second Street. The Clare County Highway garage can be seen to the left, later used as a roller-skating rink. (Beemer.)

The Jackpine Lanes bowling alley was located on what is now Old US Highway 27 South just north of Harrison. Today, it is Snowbird Lanes. (Beemer.)

Cliff's Coffee Cup restaurant on North Clare Ave (Old US Highway 27), pictured in 1945, was owned by Cliff Smith. It is the current location of the Airport Restaurant.

M-14 was the original name of the north-south highway that ran through Harrison. In the 1920s, there was a large movement with rallies and special songs chanted demanding that it be paved all the way to Cheboygan. When M-14 became a US highway years later during the Depression, it was designated US Highway 27. The highway brought Harrison prosperity as a tourist town.

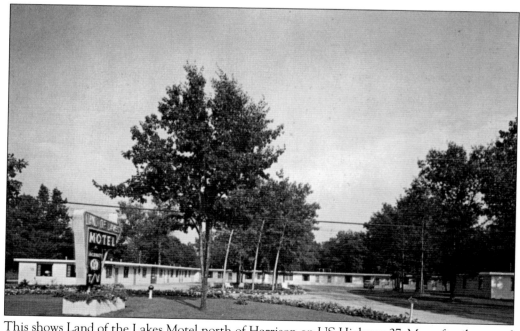

This shows Land of the Lakes Motel north of Harrison on US Highway 27. Many family-owned motels lined the highway in small towns throughout Northern Michigan. The chain hotel was not yet in existence, and many small mom-and-pop motels and camps operated successfully.

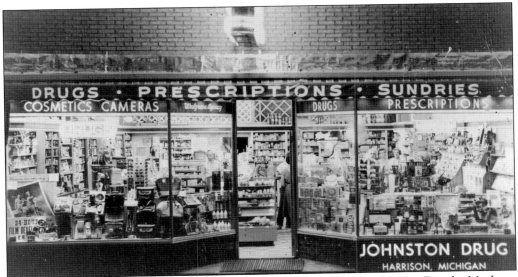

This 1950s image shows Johnston Drug in downtown Harrison on Second Street. Douglas MacLean purchased the drugstore in 1964 and moved his wife and four children from Detroit to Harrison. The pharmacy is still family owned and operated and is a popular gift shop today. (Beemer.)

Allen's Department Store sat in roughly the same downtown location as the Hughes Brothers store on Main Street. (Beemer.)

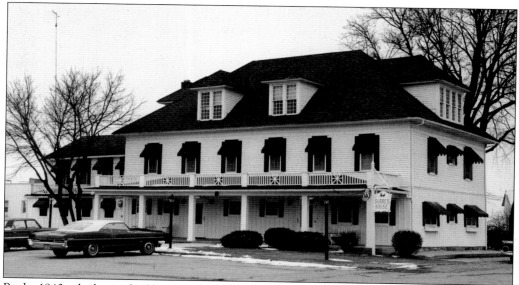

By the 1940s, the largest building left from the lumbering days stood empty and near condemnation. In 1945, Flint businessman Edward Groehsl renovated the building and renamed it the Colonial House. In 1949, Omar and Lucille Austin and Leonard and Margaret Baker became the owners and renamed it the Surrey House. (Beemer.)

This is the dining room of the Surrey House. For many years, it was the showplace of Harrison, with a statewide reputation for fine dining. Rumors that the building is haunted continue to intrigue those with active imaginations. (Beemer.)

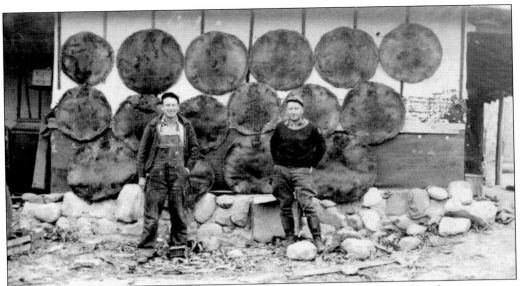

Beaver were plentiful in the 1920s and 1930s and were trapped for sport, food, and extra income. The pelts were cured, rolled, and stored. Once a year, a buyer would come and purchase the pelts. Merton (left) and Linwood Bailey are pictured here in front of home that is still owned by the Bailey family. (Courtesy of the Merton Bailey family.)

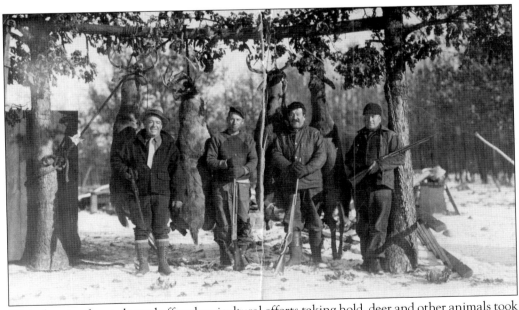

With the pine forests logged off and agricultural efforts taking hold, deer and other animals took advantage of the new habitat to thrive. Hunting brought many visitors to the area and provided sport, income, and sustenance for many area families. The same trees now support a metal buck pole on the Bailey family property. From left to right are unidentified, Merton Bailey, Nelt Bailey, and Linwood Bailey. (Courtesy of the Merton Bailey family.)

Brothers Oliver (on bike), Fred (left), and Bill (right) Beemer play at their home in Hayes Township. Carefree days spent playing outside in the woods was typical of childhood in Northern Michigan.

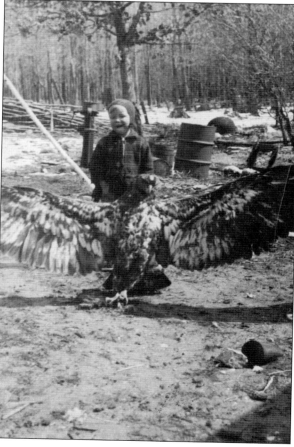

A child poses with an eagle in the 1930s or 1940s, illustrating the wildness of the area even into the 20th century. (Courtesy of the Merton Bailey family.)

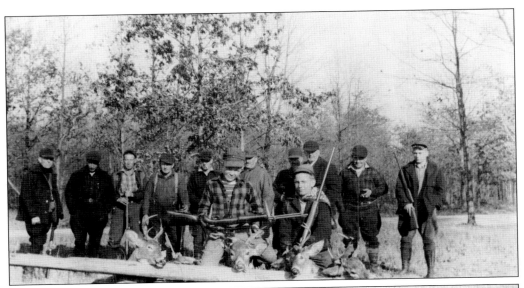

The fall hunting season was many things to local families and sportsmen coming north from the cities: a family ritual, a coming of age for young boys, a tradition. Hunting was a mainstay of the diet, and many looked forward to hunting season all year long. The young and old of the Bailey family carry on the tradition today. (Courtesy of the Merton Bailey family.)

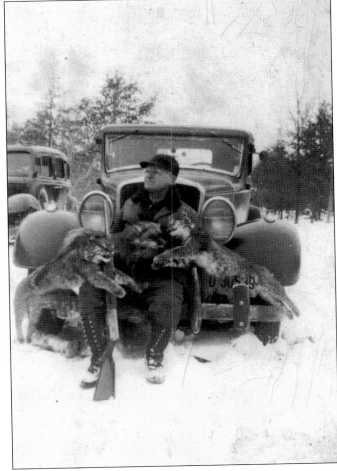

A successful winter hunt of fox and bobcat highlights wild-game hunting at its best in Northern Michigan. It is still a popular pastime. (Courtesy of the Merton Bailey family.)

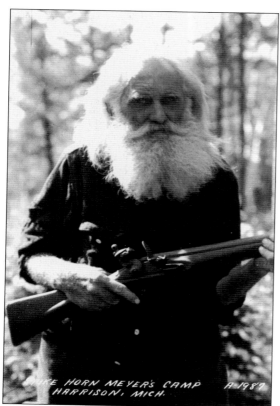

One of Harrison's most colorful characters was John "Spikehorn" Meyer. He was a showman, naturalist, politician, coal miner, tile manufacturer, furniture builder, inventor, realtor, bear hunter, lumberjack, even Santa Claus—and above all, an individualist. (Courtesy of Joe Bradley.)

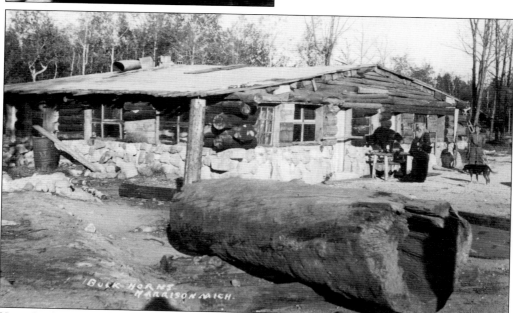

His refusal to apply for a permit to keep bears and his consistent criticism put Spikehorn at odds with the conservation department, and they became his arch nemesis. This is Spikehorn's camp around 1936, before the front porch or pillars were added.

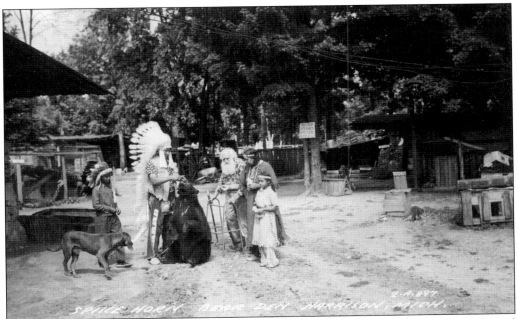

The Chambers family, from Detroit, began working with Spikehorn in 1951. They quickly assumed nicknames as part of their Indian personas: Lonnie was Chief Red Eagle; his wife, Willa Maye, was "Starr"; his son, "Little Beaver" or "Blue Eagle"; his oldest daughter, "White Horse"; and the youngest daughter, "Little Violet." (Beemer.)

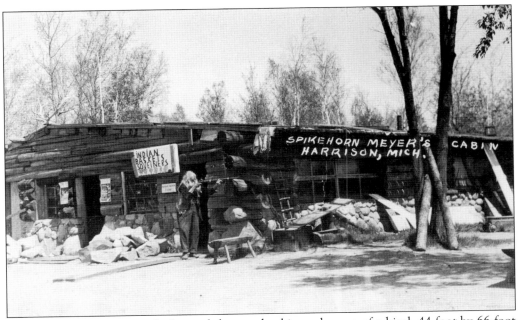

Spikehorn's camp consisted of a workshop and cabin and a one-of-a-kind, 44-foot-by-66-foot building that was his living quarters and souvenir shop and was adjacent to the bear dens. A gas pump selling White Star gasoline served to attract more visitors to stop. (Beemer.)

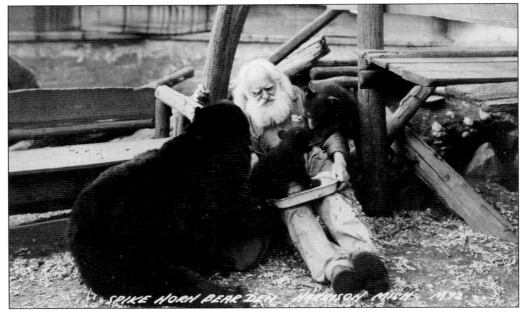

Spikehorn always had a few cubs he was raising. He called the bears he raised and cared for his best friends. He was fascinating to children and adults and always took the time to tell his tall tales and wild and amusing stories.

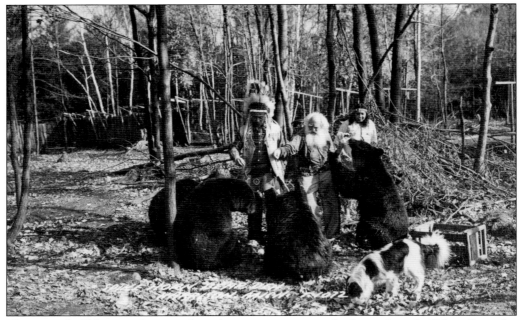

The camp held bears, of course, but also tame raccoons, chickens, dogs, buffalo, elk, and a menagerie of other wild animals. Some were even made up, such as his "Flying Red Irish Bat," which was no more than a red brick in a box up a tree that one could pay 5¢ to climb up and look into before realizing they had been had.

114

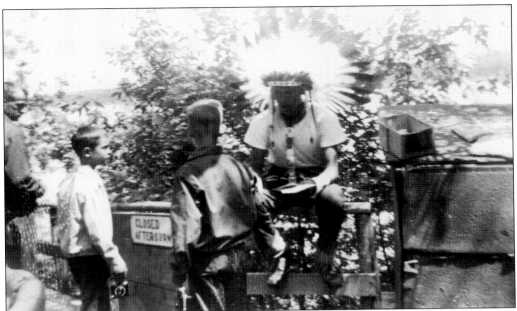

Lonnie Chambers, alias "Chief Red Eagle," visits with tourists and locals at Wilson State Park around 1952 while at odds with Spikehorn Meyer. Disagreements between Spikehorn and his associates were not unusual and usually involved nonpayment. Spikehorn would defend Lonnie and his family's claims of heritage as Native Americans in the Blackfoot tribe, and later he would say he had been informed Red Eagle was non-Indian. The Ringelberg family is shown here; oldest child, Jon H. Ringleberg (front right), was a future district judge of Clare County. (CCHS.)

A rival tourist attraction near Spikehorn's was run by a former employee. Spikehorn liked to refer to Rock's as "Rock's Monkey Ranch"; indeed, Foss Rock kept monkeys, an alligator, a bear, deer, a mule, and other small animals in his imitation of Spikehorn. Dressed as an Indian, he tried to steal business from and even pose as Spikehorn's operation. (Beemer.)

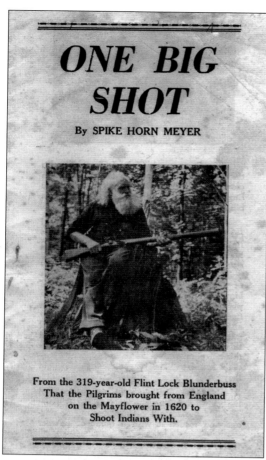

ONE BIG SHOT

By SPIKE HORN MEYER

From the 319-year-old Flint Lock Blunderbuss
That the Pilgrims brought from England
on the Mayflower in 1620 to
Shoot Indians With.

"One Big Shot" was a pamphlet of two stories sold for 25¢ in the souvenir shop. Spikehorn's stories were so good that they were printed in newspapers all over Michigan. Many tales were told about "Old Sally," a gun he claimed had come from his ancestors in Switzerland. His flintlock blunderbuss was loaned out for display but has not been accounted for since.

Spikehorn believed in a strictly limited government and stirred up much controversy in his life. His major nemeses were the conservation department and the state highway patrol. In one battle with the conservation men, he erected a sign that read, "Feed the Game Warden to the Bears." With his antics, Spikehorn was often in the press, much to his enjoyment. Shameless when it came to publicity, he would make outrageous claims that were sure to get attention. He bragged of many achievements that no one could prove or disprove. (Courtesy of Joe Bradley.)

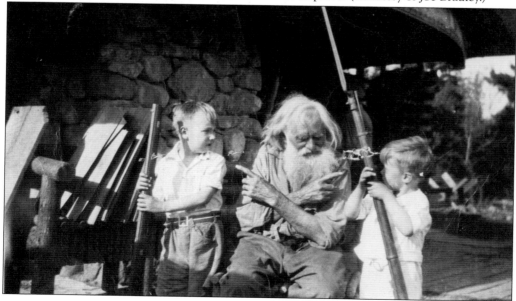

In addition to his wildlife camp at Spikehorn Creek, Spikehorn built several structures that are still in use today around the Michigan and Ohio. Cabins and fireplaces for camps and vacation retreats all bear his trademark building style. Spikehorn is seen here at Fred Bailey's sawmill. (Beemer.)

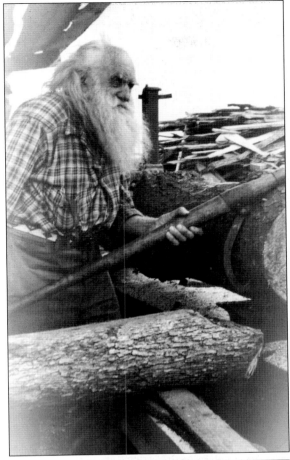

A buffalo at the camp was just one of the animals that would frequently escape. Escapees brought lots of attention, press, and free advertising in the early years, though they eventually were treated as a nuisance. (Courtesy of Joe Bradley.)

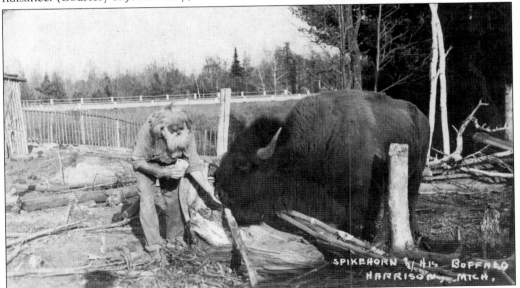

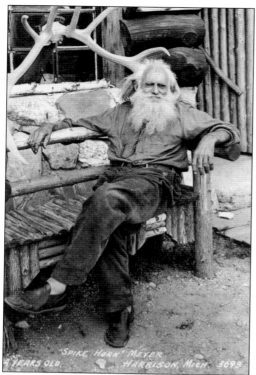

Born in Ohio but raised on a farm near Shepherd, Spikehorn came to the Harrison area in the late 1920s. On 80 acres south of Harrison, he continued various businesses, including his Green Mountain Tree Company. Already claiming to be in his 80s, he began Spikehorn's Bear Den and Wildlife Park in the 1930s. He wore homemade buckskins and sported a long beard, and his business was visited by thousands of tourists each year. (Courtesy of Joe Bradley.)

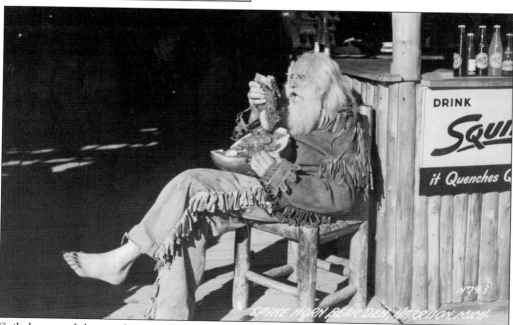

Spikehorn and those at his camp chose to live roughly to further exaggerate a woodsmen persona. He often had characters that would stop by and work for a while. "Nature Boy," a shirtless man, stayed for a summer and moved on in the fall. Others contracted to run his souvenir shop or, like the Chambers family, get in on the tourism action. (Courtesy of Joe Bradley.)

Spikehorn became so famous, and his likeness, so well known, that he was featured on four different editions of Clare County road maps. Many people around the state associate Harrison with Spikehorn Meyers, "the old guy who lives with bears." (Courtesy of Joe Bradley.)

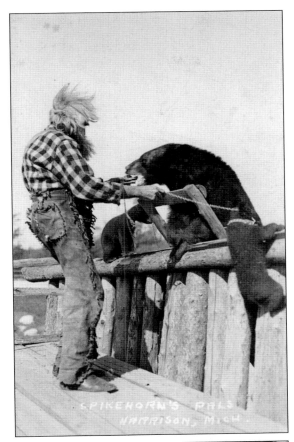

Tourists were invited to "shake hands with bears." They were also enticed by souvenirs of Canadian moccasins, photographs, baskets, and other trinkets. The bears were generally docile, and they were fed sweets, cakes, and honey. There were incidents of breakouts, scuffles, bites, and close calls with bears that gave Spikehorn publicity and created excitement for those visiting the bear dens. Several lawsuits kept Spikehorn busy defending and promoting his business and allowing him to flaunt his love of showmanship. (Courtesy of Joe Bradley.)

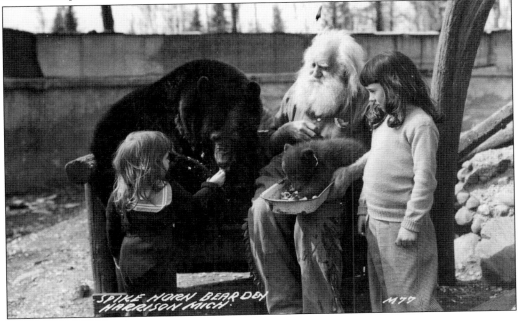

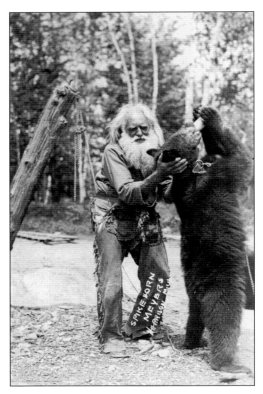

When it was not tourist season, Spikehorn traveled with his bears to publicize the bear den. He visited large cities like Detroit, Saginaw, and Lansing, and he even took his bears out of state. He brought five bears to a Detroit radio station and frequented the state capitol to drum up publicity and let the legislature know how he felt about certain issues. (Courtesy of Joe Bradley.)

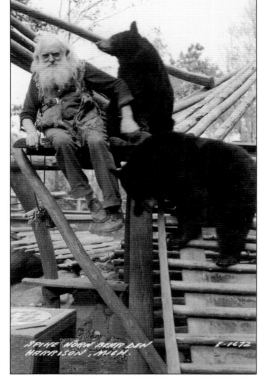

John "Spikehorn" Meyer died in 1959 at age 89 and is buried in the Salt River Cemetery near Shepherd. His tombstone states simply, "Spikehorn, Central Michigan Naturalist." Spikehorn remains one of the most fascinating characters ever to inhabit Harrison. (Courtesy of Joe Bradley.)

The rabbit was a popular feature at the wildlife park. It was equipped with a saddle, and children and adults loved to get their picture taken on it for a fee. Marie Beemer Bailey (right) was entrusted with Spikehorn's estate while he was in a nursing home. The infamous rabbit now resides at the Clare County Historical Society. (Beemer.)

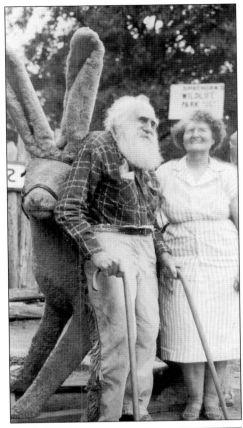

Five years before his death, an aging Spikehorn took part in the annual Fourth of July parade in Harrison. One of his bears and the Chambers family rode along with him. (Beemer.)

Knights Dairy Bar was built in 1949 by Walt and Tiny Knight on Main Street. Today, it is still a popular diner. (Courtesy of the Ferguson family.)

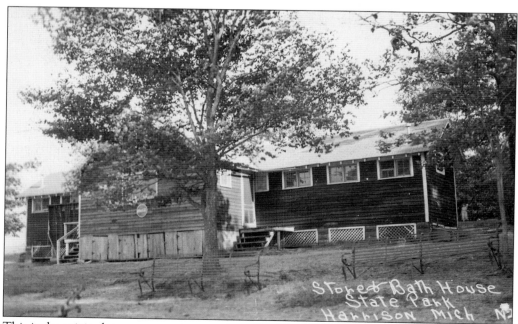

This is the original store, concession stand, and bathhouse at Wilson State Park in the 1930s. It was replaced by the Civilian Conservation Corps building and is still in use today.

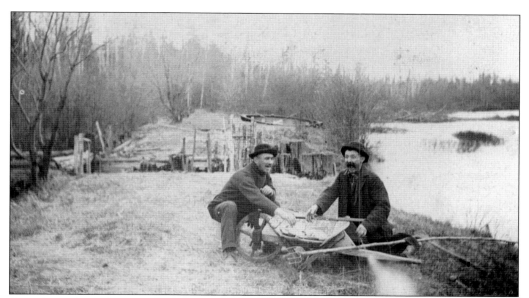

At a time when photographs were stern and serious, Oliver Gosine and a friend mug for the camera in an unknown joke. The camera string is visible in the lower right corner. Gosine moved his family to Harrison in 1880 and was a practical joker and colorful local character around town until his death in 1946. He worked as a cook in a lumber camp, an ice-crew foreman for the Wilsons, a well digger, and a sexton, in addition to working in Jim Carr's saloon, running a fruit-and-vegetable stand, and holding numerous other odd jobs. (Beemer.)

Adopting a popular pose in a photography studio during Prohibition, these young gentlemen pretend to be drinking—illegal at the time. (Beemer.)

The Harrison Elevator Company, founded in 1912 in the former location of the Wilson Lumber Company mill, fulfilled the needs of the growing agricultural efforts of the area. It was torn down in 1968. The old railroad depot sits to the right of the elevator (to the south, not seen). After the railroad discontinued service in 1944, the lumber company purchased the right-of-way for $750 and later sold it to Charles Ashcraft in 1964 for a new supermarket.

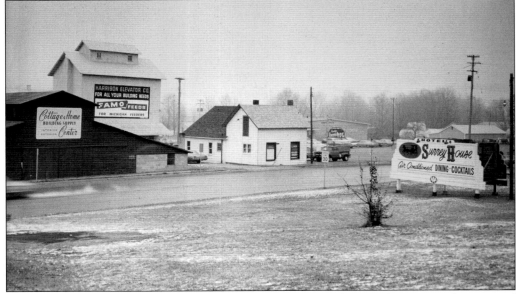

The Surrey House advertises on the corner of Beech Street and US Highway 27 in the center of town. The former office of the Wilson Lumber Company sits on the corner.

The City of Harrison displays its assets and services. From the 1940s to the 1970s, there was one policeman to patrol the city. Up until 1986, the City of Harrison maintained its own police department. Since then, it has contracted with the Clare County Sheriff's Department for law-enforcement services. The city hall and garage were built in 1967. (Beemer.)

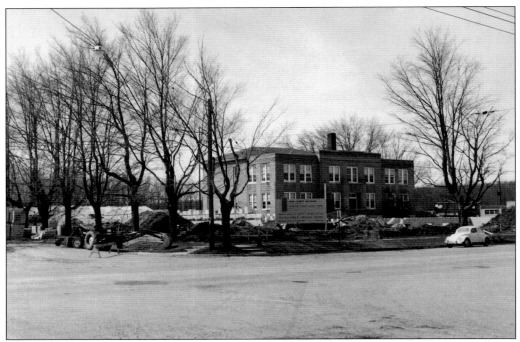

The original courthouse can be seen at the rear of the building; the front addition was constructed by the Works Project Administration in 1935. The new construction was completed in 1967, and the old courthouse was razed.

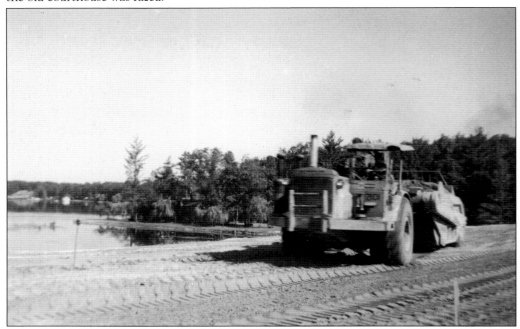

Completion of the new expressway would change Harrison and many small towns. Travelers could now bypass small towns and tourist attractions like Spikehorn's. The construction pictured here in the early 1960s is near Little Long Lake.

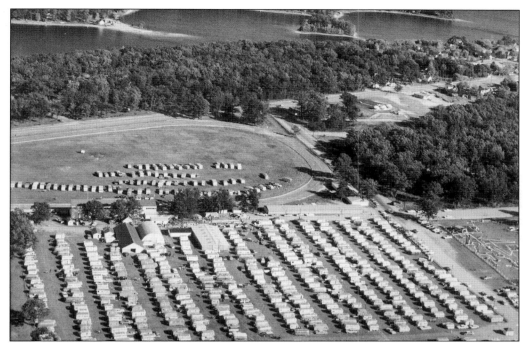

The Clare County Fairgrounds began in 1883 with 20 acres of land donated by the Wilson brothers. The flat ground could have been the wye for the railroad and mills. The grounds still feature the horse track and field popular during the county fair and many other annual events. Within walking distance to Wilson Sate Park and the Putt-R-Golf across the street, this popular destination hosted a Travel Trailer Rally, shown here in 1960.

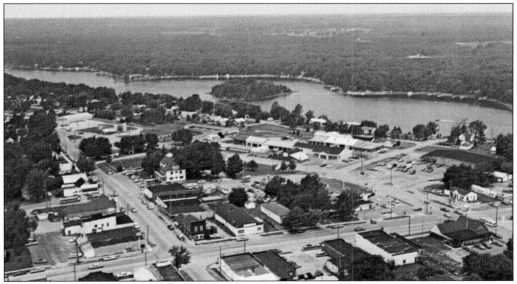

This is an aerial view Harrison in the 1960s. "When society recognizes the modest people who did the work along with those who grabbed the spotlight, history will be a greater asset to civilization." Roy Allen, born in Harrison in 1918, was a newspaperman and historian. His words best describe the hardworking citizens of Harrison that out of the wilderness built a town that thrives today.

Discover Thousands of Local History Books Featuring Millions of Vintage Images

Arcadia Publishing, the leading local history publisher in the United States, is committed to making history accessible and meaningful through publishing books that celebrate and preserve the heritage of America's people and places.

Find more books like this at
www.arcadiapublishing.com

Search for your hometown history, your old stomping grounds, and even your favorite sports team.